D1284718

POSTCARD HISTORY SERIES

Homestead and Mifflin Township

POSTCARD HISTORY SERIES

Homestead and Mifflin Township

Jim Hartman
with the Homestead and Mifflin Township Historical Society

Copyright © 2005 by Jim Hartman with the Homestead and Mifflin Township Historical Society
ISBN 0-7385-3935-X

Published by Arcadia Publishing
Charleston SC, Chicago IL, Portsmouth NH, San Francisco CA

Printed in Great Britain

Library of Congress Catalog Card Number: 2005931904

For all general information contact Arcadia Publishing at:
Telephone 843-853-2070
Fax 843-853-0044
E-mail sales@arcadiapublishing.com
For customer service and orders:
Toll-Free 1-888-313-2665

Visit us on the internet at http://www.arcadiapublishing.com

CONTENTS

ACKNOWLEDGMENTS

This book shows a great bygone era of our local history and preserves it for future generations. Research for the captions of the cards was conducted at the historical society. This is not meant to be a scholarly work but one that demonstrates what was then and what is now.

Many of the postcards in this book were supplied by donations to the Homestead and Mifflin Township Historical Society from the Charles Wharenberger family, Clarence "Bud" Folk family, and James Leerberg family. Special thanks go to those who shared their collections for documentation: Dan Burns, Chris Fuhs, Richard Gaetano, Jim Hartman, and Nathan Zapler.

INTRODUCTION

When Allegheny County was formed in 1788, seven townships were created within its boundary and named as follows: Elizabeth, Mifflin, Moon, Pitt, Plum, Saint Clair, and Versailles. By 1800, Allegheny County had been reduced to its present size. The first meeting minutes after the formation of the county describe Mifflin as "beginning at the mouth of Street's run, thence up the Monongahela river to a line of the county, and by the said line to the line of St. Clair township." The original township was an area of some 31.8 square miles.

The first settlers in this area arrived in the 1760s and farmed as a way of life. The early inhabitants found that the land abounded in massive forests, which were theirs for the taking, and that the fertile farmlands along the rivers gave bountiful crops. Under the ground, they found an abundant new fuel: coal.

Mifflin Township was split in half in 1828, and Jefferson Township was formed. The Hays family started mining coal along the Streets Run valley in the 1820s. The city of Pittsburgh bought property from the McClure family in 1850 for the construction of a poor farm along the river in the area known as Homestead.

The Pittsburgh, Virginia, and Charleston Railroad, working its way into the area in 1871, brought a building boom to the area. The Homestead Bank and Life Insurance Company bought property from the McClure and West families and laid out the first lots to sell to workers in the same year. The Kloman brothers erected a foundry on property purchased in 1881 from the McClures and worked with the Pittsburgh Bessemer Steel Company to produce steel. About the same time, Bryce-Higbee also built its glassworks. Homestead applied for a charter for incorporation as a borough in 1880. Carnegie Steel bought the Pittsburgh Bessemer Steel Company in 1888, renaming it the Homestead Works, and the area flourished with more workers. The great Homestead Steel Strike came in 1892.

The small village of German Town was beginning to flourish in the 1880s, when the Duquesne Steel Company was formed and started to produce rails. The Howard Glass Works and the Duquesne Tube Works were also started at this time. Workers were not only pouring in to build these foundries but also to work in them. The boom was on, and this small village was incorporated as the borough of Duquesne in 1891. The Carnegie Steel Company purchased Duquesne Steel in 1899 and renamed it Duquesne Works.

The influx of new residents in the East Homestead area of Mifflin Township brought about the formation of another new borough in 1901, known as Munhall. To the west of Homestead, the Mesta Machine Company erected its works in the 1890s, bringing more workers to the area. The borough of West Homestead was also incorporated in 1901.

Many coal mines operated in Mifflin Township, feeding the steel mills, along with those started in the Streets Run area. Families continued to arrive, attracted by the mine work, and in 1902, Hays Borough was carved out of portions of Mifflin and Baldwin Townships. The small villages of Stonesboro and Amity included many of the mines owned by the Dravo and Risher families. Due to the increased population, these areas incorporated as the borough of Dravosburg in 1903.

The population started spreading into the farming areas of Mifflin Township up from Munhall, and Whitaker was formed as a borough in 1904. The spread of population moved inward and up into the hills of Mifflin Township when Lincoln Place started building homes. At this same time, the Homestead Land Company purchased many small farms in the area known as Homestead Park. The firm built an electric railway line to entice workers to a trolley park it had constructed. While enjoying themselves there, workers were persuaded to buy lots that the land company had for sale. Homestead Park experienced a heavy influx of inhabitants, and through the years both it and the New Homestead area tried to incorporate as boroughs of their own. The people of Lincoln Place and New Homestead were annexed as the 31st Ward of Pittsburgh in 1929. The Homestead Park area of Mifflin Township was annexed by the borough of Munhall in 1929 as well.

Jefferson Township, once part of Mifflin Township, was also having its growing pains. Workmen arrived to work in the Elizabeth boat industry that spread itself across the river into West Elizabeth, which was incorporated as a borough in 1848. The coal industry also brought more workers for the mines in the Blair and Wilson areas of Jefferson Township in the 1880s. Clairton was incorporated as a borough in 1903, Wilson in 1907, and Blair (North Clairton) in 1915. In 1922, these three boroughs were joined into a third-class city known as Clairton. The population of Jefferson Township increased. The Pleasant Hills section of Jefferson Township grew into a bedroom community and was incorporated as a borough in 1947. Jefferson Township became a borough in 1952.

In the early 1900s, townships were at the mercy of those who wished to form their own community. The township commissioners saw this and asked the state of Pennsylvania to pass legislation against this happening. Mifflin Township made history in the state of Pennsylvania in 1944, when it became the first township to be made a borough.

Today the area is devoid of the coal mines and the great steel industries that were once so prevalent and the mainstay of every community's income. What is left are the children of these early hardworking immigrants from the Old World who strived for the American Dream. They left their heritage in the present-day communities of Clairton, Dravosburg, Duquesne, Hays, Homestead, Jefferson Hills, Lincoln Place, Munhall, Pleasant Hills, West Elizabeth, West Homestead, West Mifflin, Whitaker, and part of Baldwin.

One

STREET SCENES

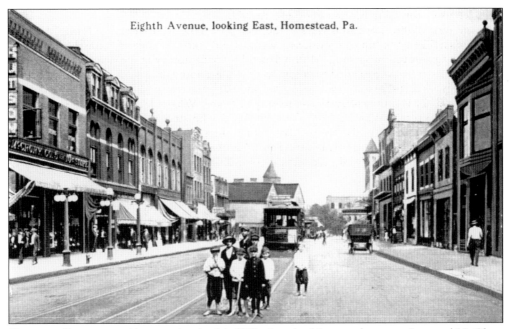

Eighth Avenue, looking East, Homestead, Pa.

Homestead's young residents gather in this 1910 view, looking east between Ann and McClure Streets. McCrory's appears to the left, and the building with the spheres on its peak is Woolworth's. The pointed roof in the center is the peak of the Homestead Public School. Two streetcars of the Homestead and Mifflin Electric Railway wait patiently for the photographer to complete his task.

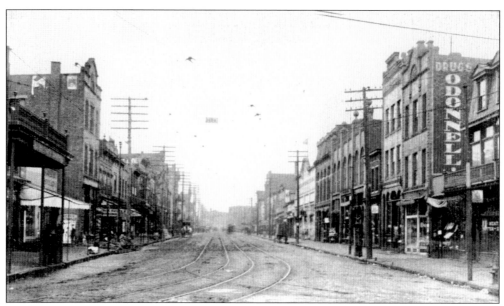

This early-1900 postcard view, looking west from McClure Street in Homestead, shows East Eighth Avenue. O'Donnell's Drug Store, to the right, was a well-known and established business on the avenue. Next door is the F. W. Woolworth building.

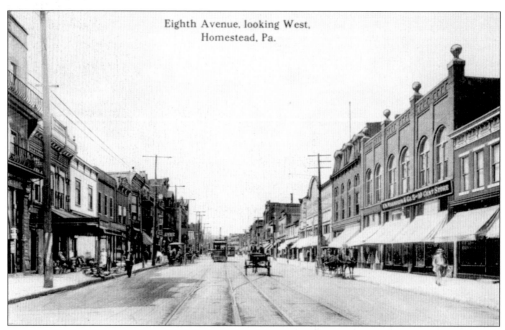

In this view, looking west along East Eighth Avenue in Homestead, the building on the right is the F. W. Woolworth store. Today this site is the home of the Levine Hardware Company.

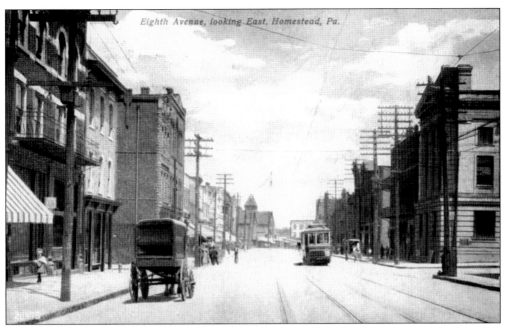

Eighth Avenue, looking East, Homestead, Pa.

A trolley passes the Monongahela Valley Trust Bank at the corner of Ann Street in Homestead in 1908. The view looks east toward McClure Street. Automobiles were few and far between at this time, and the horse-drawn wagon was the main source for deliveries to area stores and homes.

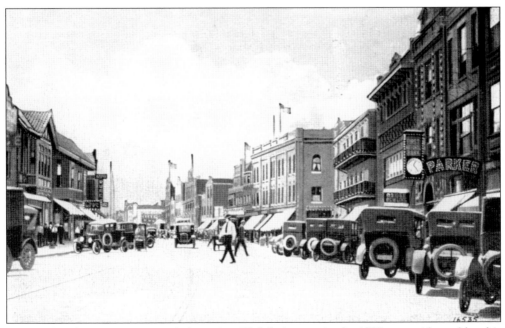

Diagonal parking was permitted along East Eighth Avenue in the 1930s, as evidenced by this postcard. The view looks west along Homestead's main thoroughfare. The Realty Building, right center, was demolished in the 1930s and rebuilt, becoming the Monongahela Valley Trust Bank and later the Pittsburgh National Bank.

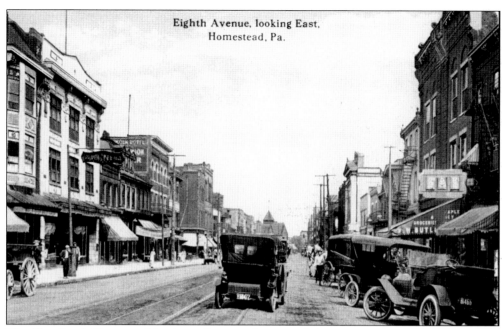

The "bustling" Homestead business district of East Eighth Avenue is depicted in this view looking east from Amity to McClure Streets in the 1920s. The Monongahela Valley Trust Bank appears in the right center.

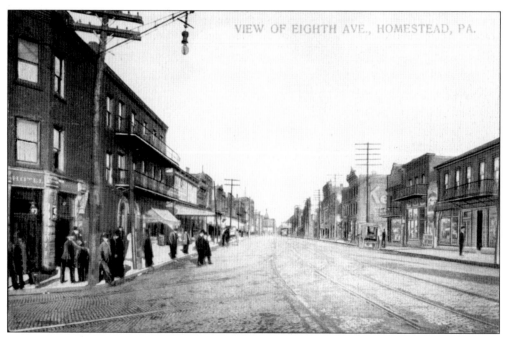

This postcard view, dated 1905, looks east from Amity to Ann Streets, showing Homestead's East Eighth Avenue. This street became the main shopping district at the beginning of the 20th century. At the time, it was paved with brick, and the electric railway system provided transportation between Pittsburgh and other local communities.

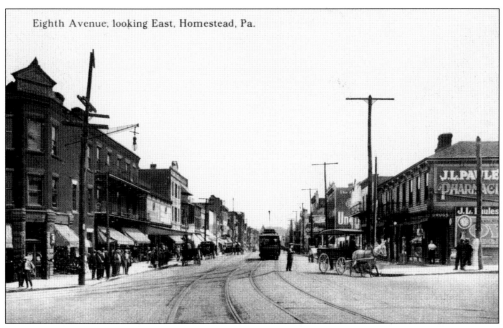

Eighth Avenue, looking East, Homestead, Pa.

From Homestead's early days, the intersection of East Eighth Avenue and Amity Street was one of the busiest. Above, a trolley heads east to Ann Street in 1910. On the right corner stands the J. L. Paule Pharmacy, and across the street is the Hotel Lafayette. The 1930s postcard below shows the same intersection, with Mays Drug Store taking over the previous business. It later became Moxley's Drug Store. Across the street is Sol's Clothing Shop, located on the first floor of the Hotel Lafayette. Making a turn to the left would take one to the First Ward, "below the tracks," where the Brown's Bridge crossed the Monongahela River.

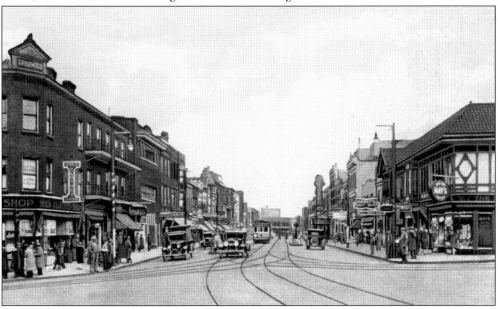

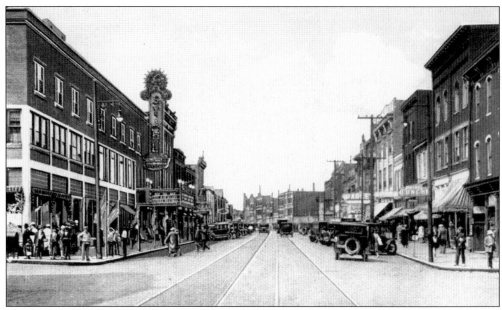

John Stahl's Million Dollar Theatre opened in Homestead on November 11, 1925. Stahl's was known for its state-of-the-art movie projection and sound system. Marathon dances were held in the basement in the dance land during the 1930s and 1940s. Tituts Hodder took over the building in the 1940s, when hard times hit, and renamed it the Leona Theatre for his daughter. The structure was demolished in 1984 and is home of a national convenience store today.

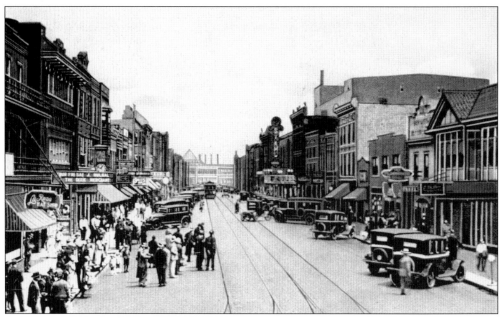

People anxiously await the streetcar approaching the stop on East Eighth Avenue and McClure Street in the 1930s. Diagonal parking was the vogue at that time, and safety islands were still to come in Homestead.

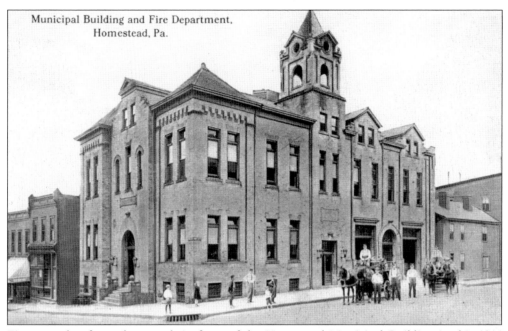

Municipal Building and Fire Department,
Homestead, Pa.

Firemen relax for a photograph in front of the Homestead Municipal Building in this 1914 postcard. The building, located at the corner of Amity Street and East Ninth Avenue, was the home of local government and the police and fire departments. Many of those breaking the law were incarcerated in the jail in the basement.

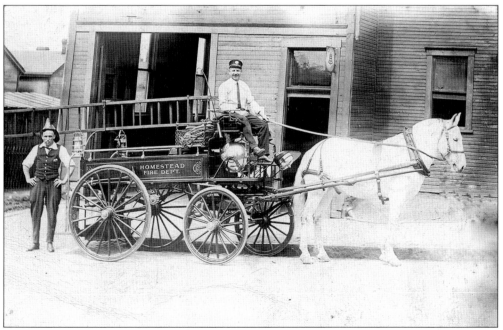

This real photo postcard of two Homestead firemen was taken in front of the station on Fourth Avenue in Homestead's First Ward in the early 1900s. The station was equipped with the newest high-tech equipment of the time: the telephone.

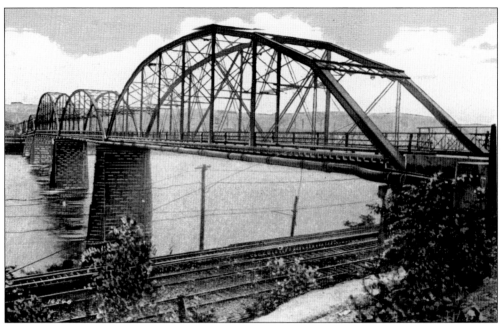

Brown's Bridge, a camel-truss span costing $150,000 to build, opened in 1895. It was constructed by a group of investors with Capt. Samuel Brown and under the auspices of the Squirrel Hill Railway Company. The structure rose 54 feet above the river and spread 1,300 feet over five spans. The view above, taken in the 1920s, shows the span from the Pittsburgh side to the Homestead side across the river. The view below, from an early-1900s card, depicts Homestead and the mills with the boatyards of Capt. Samuel Brown along the river.

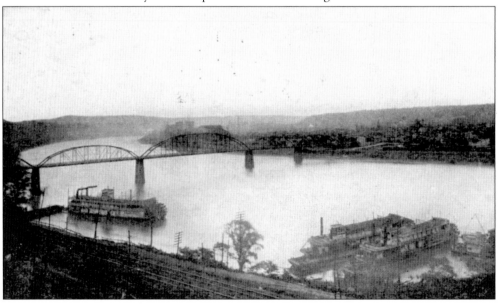

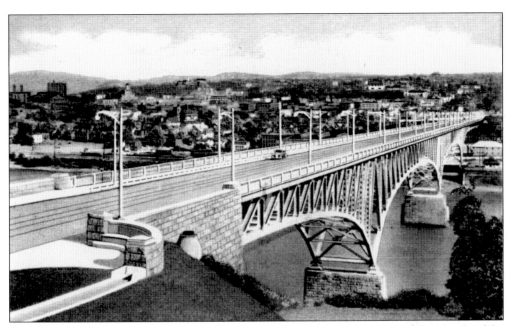

This view of the Homestead High Level Bridge reveals Homestead from the Pittsburgh side of the river. The bridge opened on November 20, 1937, with a grand parade and dedication services. It spans the Monongahela River and railroad tracks in Homestead's First Ward. Renamed the Homestead Grays Bridge in 2001 in tribute of the famed local African American baseball team, the bridge now serves thousands of cars daily as the entrance into today's Waterfront shopping complex.

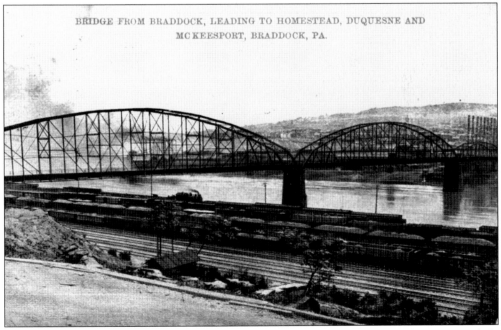

Before the present-day Rankin Bridge, the West Braddock Bridge crossed the Monongahela River from the borough of Whitaker to Rankin. A truss bridge similar to the Brown's Bridge, it was replaced with a spacious four-lane span in the 1950s.

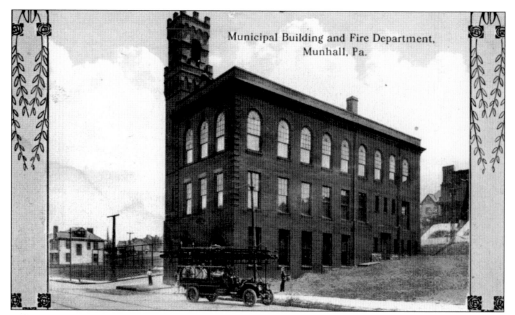

Municipal Building and Fire Department, Munhall, Pa.

When it opened in 1904, Munhall was proud of its new municipal building with its Norman castle belfry. This building was located at the corner of Eighth Avenue and Andrew Street. Its three stories included municipal offices, a meeting room, police department, jail, and fire department. Here, the borough's firemen take a moment to pose for the photographer.

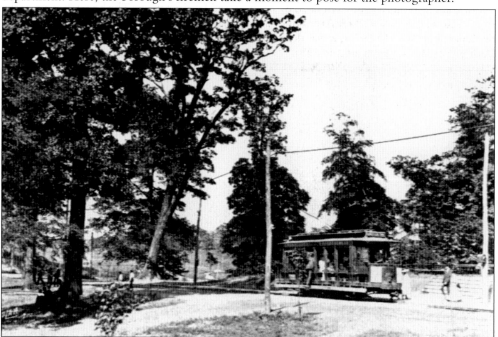

In this 1908 real photo postcard, a Homestead and Mifflin Electric Railway Company trolley makes its way along Main Street in the Homestead Park area. The Homestead Park Land Company formed in 1902 and started development of this section. One of its highlights was the electric railway system that provided transportation for those who worked in the mills of Homestead. A trolley park was also built along its line on Main Street.

18

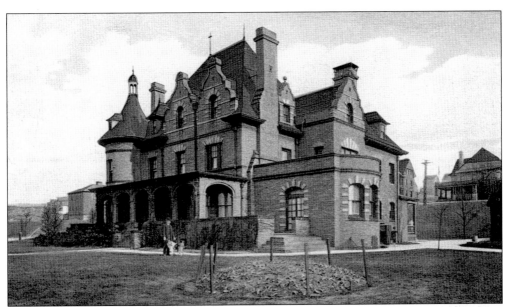

The Library Estates was an exclusive area developed by the Carnegie Land Company in the borough of Munhall during the early 1900s. The land came with strict rules on the construction and type of dwellings that were to be built upon it. The Carnegie Steel Company built an immense home for the Homestead Steel Works superintendent on a whole block area between Tenth and Eleventh Avenues, bounded by Andrew and Louise Streets. The home, known as the Hunt Mansion, was named for Azor Hunt, the first superintendent of the mills to take full-time residence there. By the 1970s, it was demolished; today a senior care complex occupies the site. Both postcards date from around 1910.

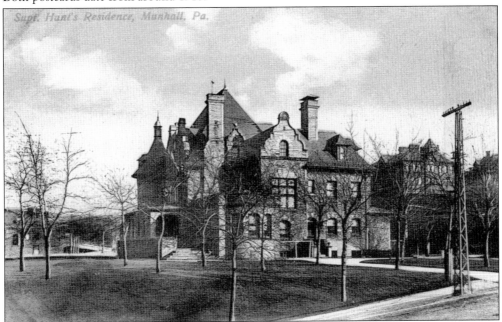

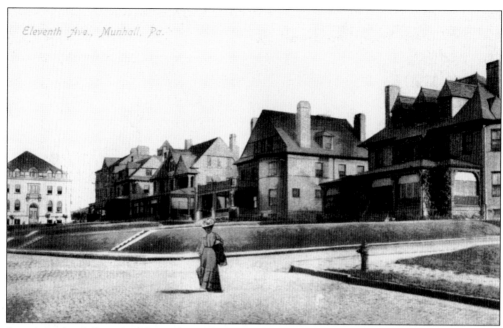

Superintendent's Row was located on Eleventh Avenue between Andrew and Louise Streets in Munhall's Library Estates. These were elaborate homes constructed for living by the immediate general superintendents of the Homestead Steel Works. There were five homes on this block at one time. The Munhall Public School is the white building on the left. Today all these lots are vacant.

This 1920s postcard depicts Margaret Street in the Library Estates area. This view looks south from the rear of the Carnegie Library, where two young ladies plan to make a visit.

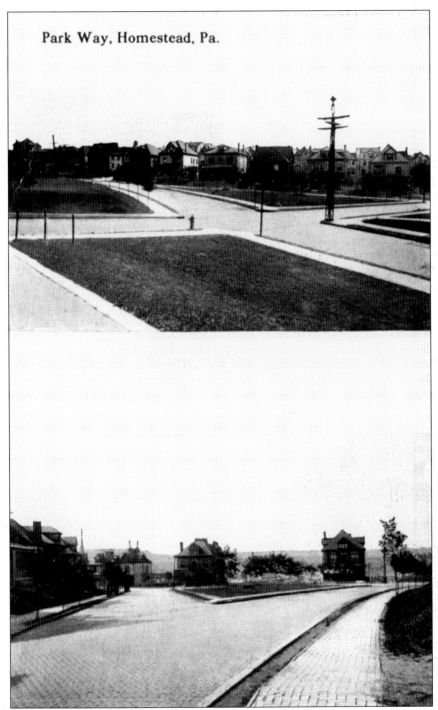

Park Way, Homestead, Pa.

Park Way lies directly to the rear of the Carnegie Library in the Library Estates in Munhall. The upper view looks south to Twelfth Avenue, and the lower view looks north toward the library and Eleventh Avenue. A small park is located in the triangular area between Margaret Street and Park Way. Today it features beautiful landscaping and a working water fountain maintained by the residents of the area.

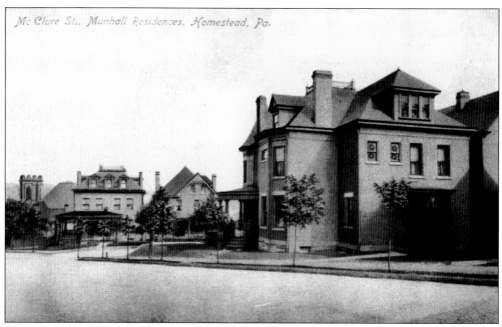

The Library Estates ended at McClure Street, which is also the border line of Munhall and Homestead. This 1921 postcard view, looking north, shows homes at Tenth Avenue and McClure Street.

This postcard view, published by the *Daily Messenger* around 1905, looks east on East Tenth Avenue in Homestead toward McClure Street. A family enjoys a leisurely stroll along the tree-lined avenue.

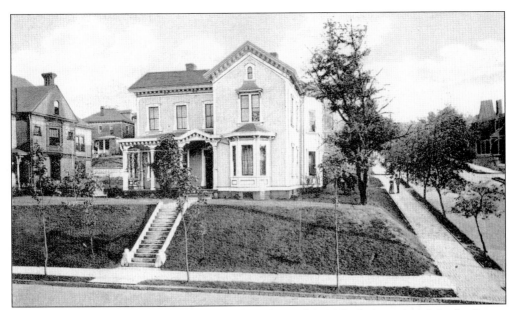

The McClure Homestead, which stood at the corner of East Ninth Avenue and Amity Street, is pictured here in 1915. Located across the street from the Homestead Municipal Building, the home was razed in the 1940s; today a playground occupies this area.

In this 1908 real photo postcard of Whitaker, the Methodist church appears to the right.

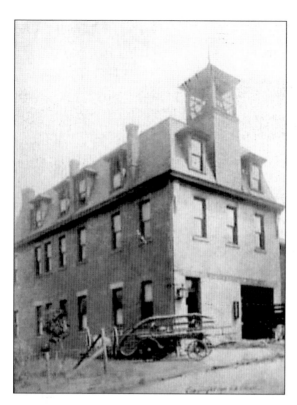

In 1896, the Whitaker Volunteer Fire Company was established to protect the property and lives of the residents of the town of Whitaker. This real photo postcard shows the newly constructed building in the early 1900s.

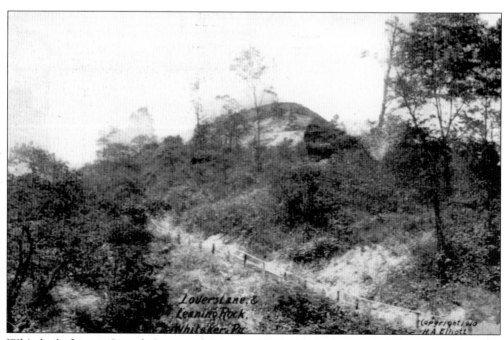

Whitaker's famous Lover's Lane and Leaning Rock are depicted in this 1910 postcard by H. A. Elliott.

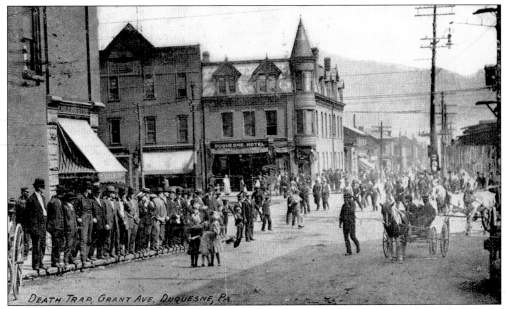

Entitled "Death Trap, Duquesne, Pa.," this real photo postcard dates to the early 1900s. Looking down West Grant Avenue to South Duquesne Avenue, the view shows workers leaving the Duquesne Steel mills on the right fenced area. Across the street is the Duquesne Hotel and the area known as "below the tracks." In the left foreground stands the Downey Building, housing the Eagle Drug Store. People had to cross two electric railway tracks and four or five railroad tracks to get to the other side of the street—truly a death trap.

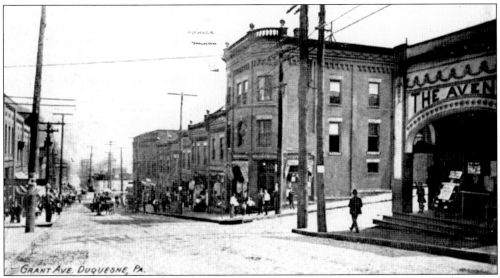

This early-1900s real photo postcard depicts West Grant Avenue at the corner of North and South First Streets. At this time, Duquesne was already realizing that brick construction was a much better form of fire protection. In the right foreground are the Avenue News building and the entrance to the Magic Lantern Theatre, one of the town's first nickelodeons. At the bottom of the hill are the Duquesne Steel mills of the Carnegie Steel Company. A delivery wagon slowly travels up from South Duquesne Avenue while local residents shop the business district.

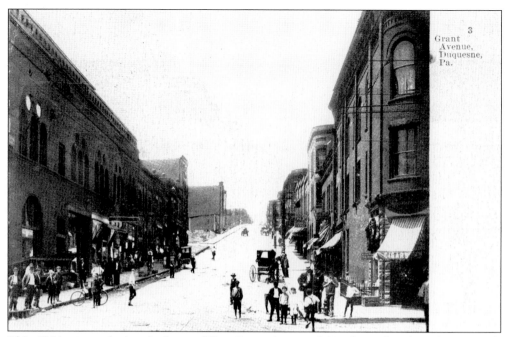

This 1904 postcard view looks up West Grant Avenue from the railroad tracks at South Duquesne Avenue. The First National Bank, on the left, was formed by the Crawford family and other local investors. The Downey Building stands across the street on the right. Horse-drawn vehicles are the norm of transportation.

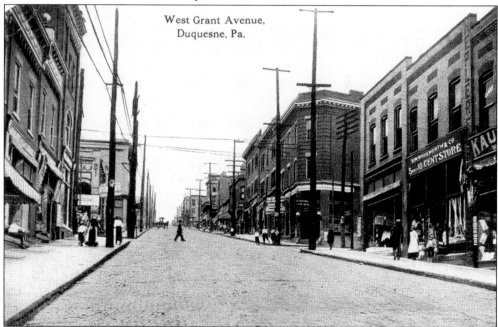

Dated 1914, this view of West Grant Avenue in Duquesne looks toward North and South First Street. In the center right stands the Duquesne Trust Company building without its landmark exterior timepiece. Kaufmann's Clothing Store and F. W. Woolworth's appear on the right. Across the street is the Magic Lantern Theatre.

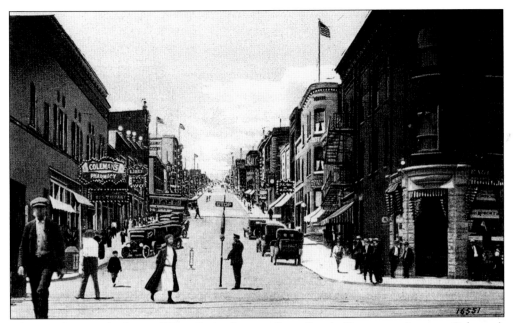

This 1920s view looks up West Grant Avenue from South Duquesne Avenue. Coleman's Pharmacy, on the left, is located in the First National Bank building, and across the street is the Eagle Pharmacy. One of Duquesne's finest directs the already increasing flow of automobile traffic at this very busy intersection. In the center left, a rare Duquesne and Dravosburg Electric Railway trolley makes its way onto South First Street.

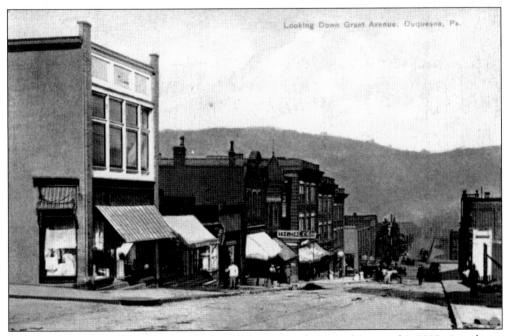

Looking down West Grant Avenue from North and South Second Street, this 1915 view shows more of the business street in Duquesne.

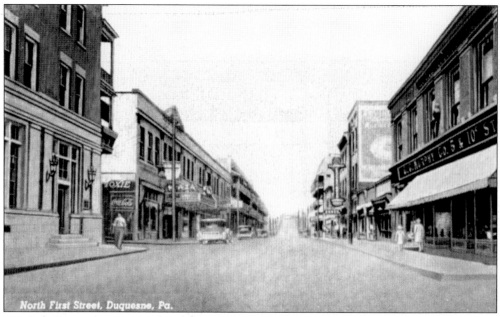

North First Street was one of the main business areas in the city of Duquesne, as evidenced by this 1930s postcard. The G. C. Murphy Company offered inexpensive items to its buying public. To the right of Murphy's was Alexander's Market (not shown), one of the largest all-in-one markets. The Moxie and Coca-Cola signs are posted on the side of Woody's Drug Store in the Plaza Theatre building. Other businesses on this street were Levine Hardware, Finkelstein's Clothing, Kroger Market, Stone's Hardware, and Jerry and Bud's Donuts, where everyone stopped in the morning for a coffee and a glazed or sugar sweet.

The Oliver Elementary School, shown in this 1912 postcard, was located on North Second Street in Duquesne. An automobile travels on the street as the youngsters in front of the school look on. In the distance is the Monongahela Valley Trust Company building, with the flag on its peak.

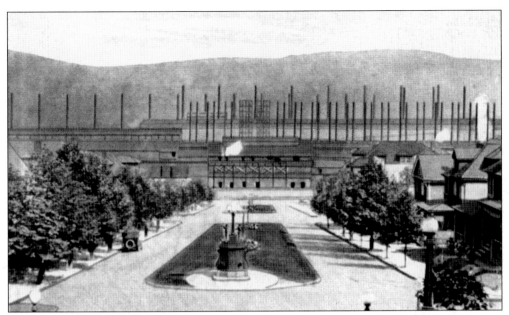

Library Place was aptly named because it provided an entrance to the Carnegie Library of Duquesne. This 1920 postcard provides a view from the steps of the library toward the Duquesne Steel mills. In the second decade of the 20th century, streets were beautified by the planting of sycamore trees, providing shade and character to the steel town.

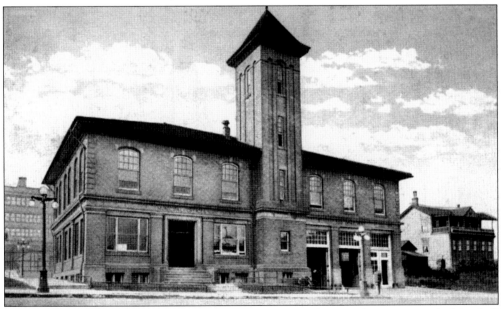

Pictured here in the 1920s, the Duquesne City Hall on South Second Street sported a large bell tower and housed the city's offices, police department with jail, and fire department. The newly constructed Duquesne High School is shown directly behind the building. Today the city hall is one of the lasting landmark buildings in the city.

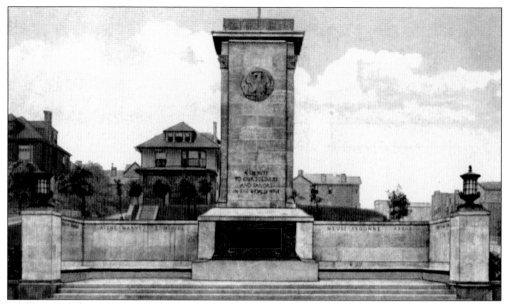

In 1920, the city of Duquesne built a very impressive park in remembrance of those who had served in World War I. The park was located along West Grant Avenue from South Second to South Fourth Streets. The names of all the veterans of that war were engraved on tablets in their memory. The monument was demolished for expansion of the Duquesne High School in the 1990s, and a smaller edifice was erected just below it.

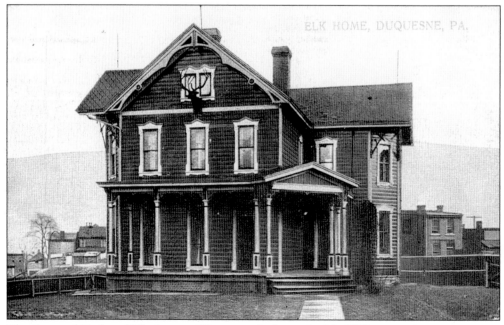

The Fraternal Order of Elks home of Duquesne is shown in this 1915 postcard.

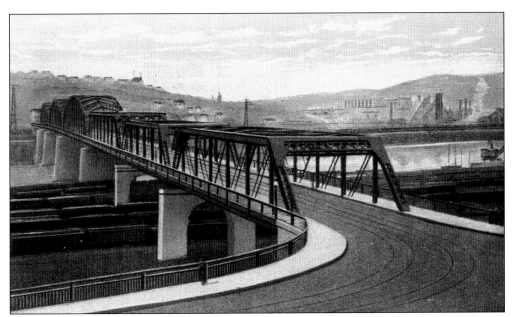

The McKeesport Duquesne Bridge, seen here in the 1930s, was built in 1928 and opened with a grand parade in 1929. This bridge replaced one that had been built in the 1890s for streetcar use.

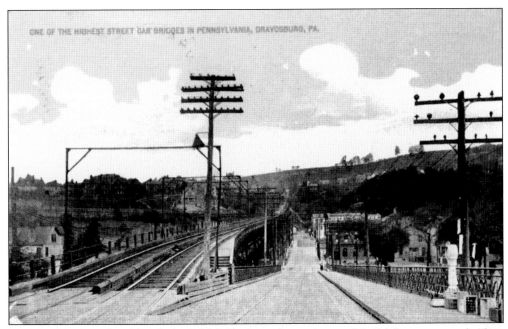

Pictured in 1915, the Dravosburg Bridge has been deemed one of the highest streetcar bridges in Pennsylvania. The Whipple truss span was built in 1889 to carry electric railway cars and vehicular traffic. The bridge connected Dravosburg with Reynoldton, the present-day 10th Ward in the city of McKeesport. The famous streetcar viaduct, added around 1898, brought the electric railway to a level spot high above the river.

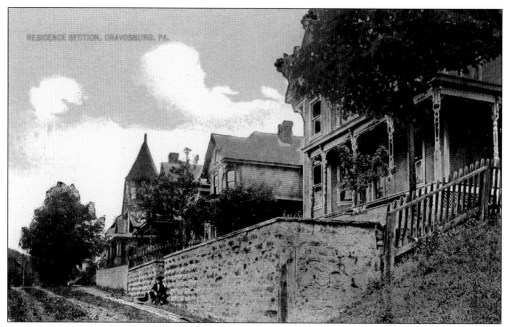

This 1910 postcard shows some of the elaborate residences along Park Street and Sherman Avenue in Dravosburg.

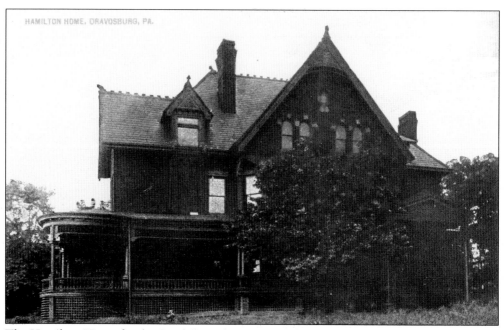

The Hamilton Home for the Aged (later the Queen Esther Home for Boys), depicted in 1912, was located on Maple Avenue. Lots of local boys played ball on the lawn after the home was closed. The building later became a Pennsylvania State University extension site and then burned down in the 1960s. The new Methodist church stands here today.

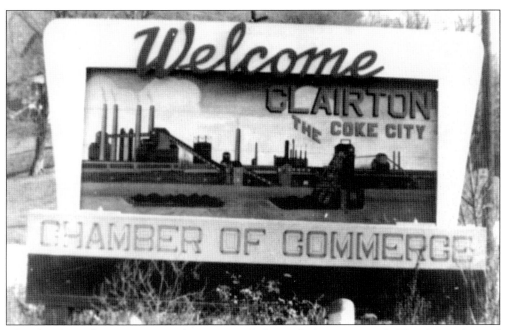

The chamber of commerce in Clairton issued this real photo postcard. The sign welcomed those who entered "the Coke City."

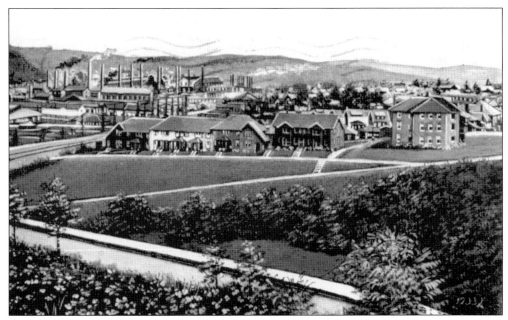

This 1920s postcard gives a panoramic view of the Wilson District in the city of Clairton.

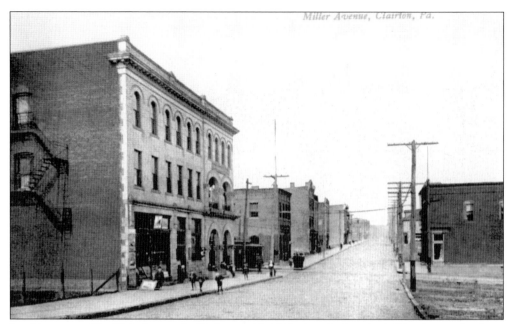

Looking toward St. Clair Avenue in Clairton, this 1910 view depicts the Miller Avenue business district. The Clairton Inn is to the left.

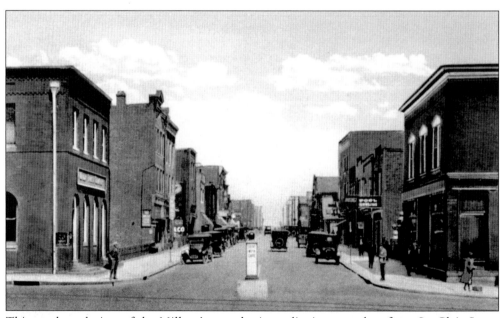

This northward view of the Miller Avenue business district was taken from St. Clair Street in 1920.

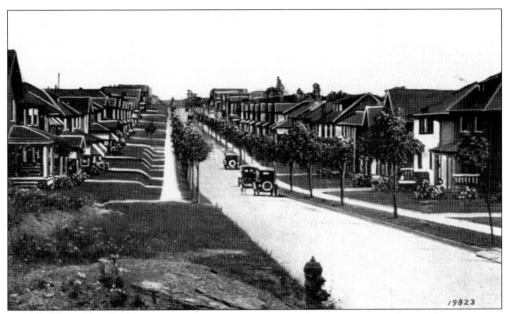

Van Kirk Street was one of the large residential communities that developed in Clairton during the 1920s.

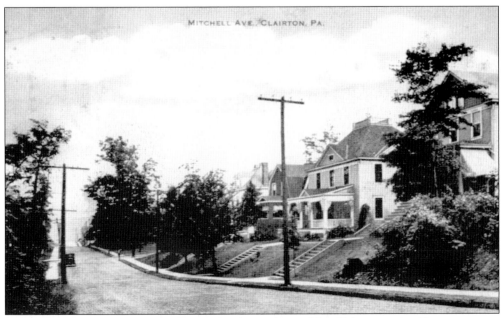

Mitchell Avenue sported elegant homes for the workers of the Clairton steel mills.

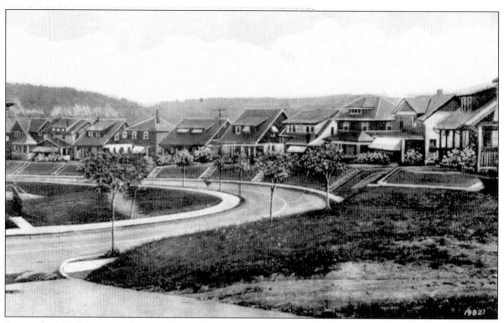

Pennsylvania Avenue, a fine residential area in the Wilson District of Clairton, is shown in this 1920s postcard.

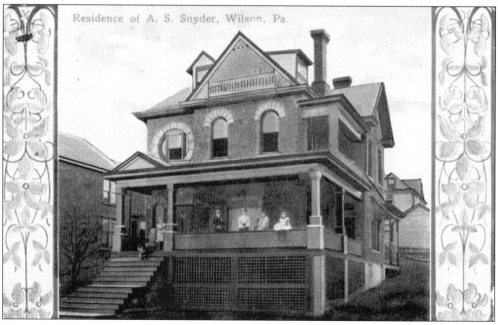

The A. S. Snyder home in the Wilson District of Clairton appears here in 1912.

Two

INDUSTRY AND BUSINESS

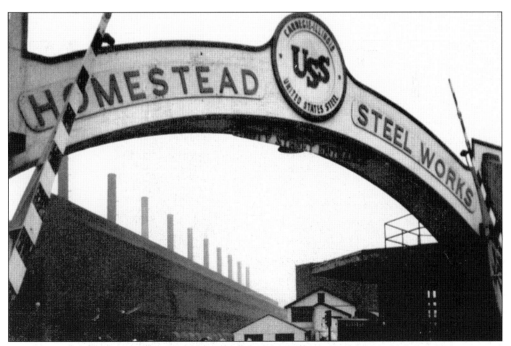

The Homestead Steel Works sign at the Amity Street entrance was known to thousands who entered to labor in the mill over the years.

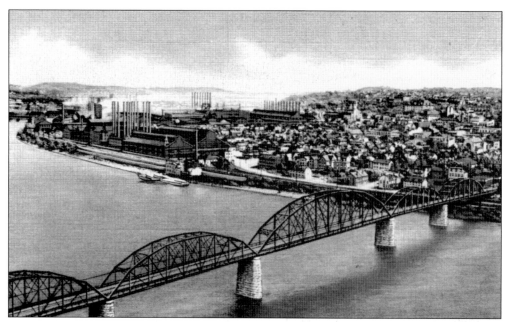

The 1930s view of the Homestead Steel Works and the First Ward is framed by the old Brown's Bridge. The First Ward was demolished in 1941 to allow the expansion of the mill for war production.

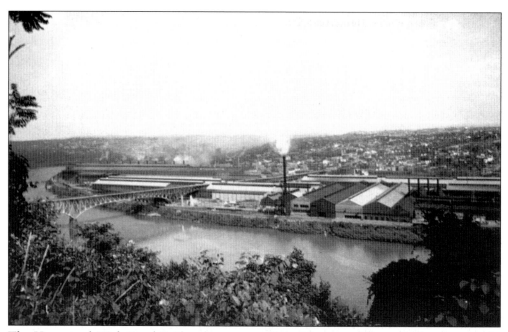

The Homestead High Level Bridge, later renamed the Homestead Grays Bridge, crosses the expansive Homestead Steel Works in this panoramic 1950s chrome color postcard.

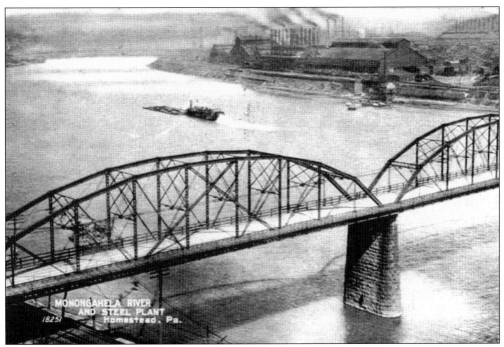

A riverboat passes the Homestead Steel Works near the old Brown's Bridge in the 1920s.

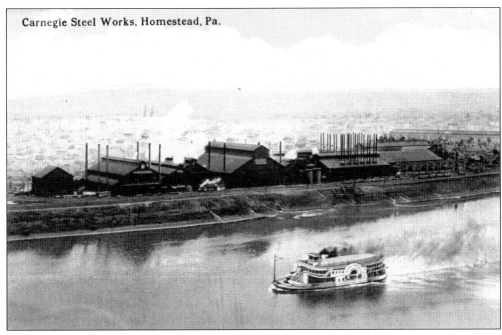

On its way to Duquesne, a steamboat churns past the Homestead Steel Works in this view from the 1920s.

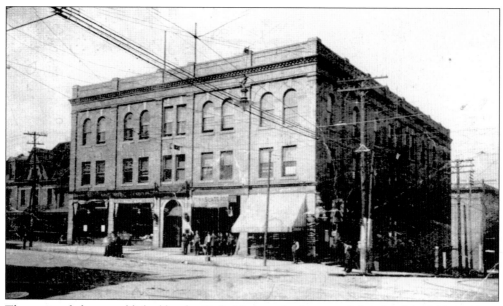

The postcard above, published by the *Daily Messenger* in the second decade of the 20th century, shows the Realty Building, located at the corner of East Eighth Avenue and Amity Street. The building was a landmark until the 1930s, when it was razed and the new home of the Monongahela Valley Trust Company Bank built in its place, as shown below. The structure also housed the Pittsburgh National Bank at one time. Today it houses professional offices.

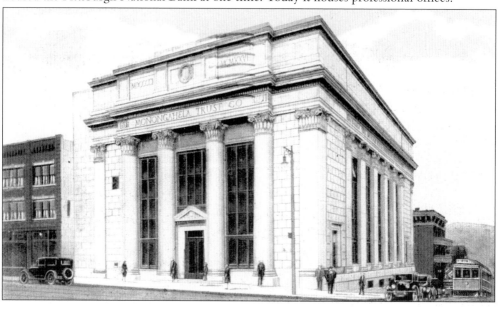

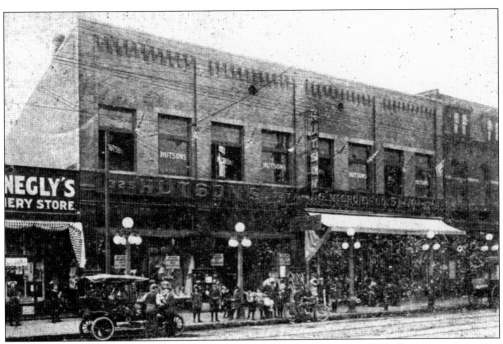

Hutson's, shown above in 1914, opened for business on East Eighth Avenue in Homestead in 1896. The department store used its photograph as an advertisement to prospective customers. The card below, announcing the store's 20th anniversary sale, was sent to a customer in Homeville.

Post Card

DEAR MADAM:—

Come help us celebrate our 20th Anniversary Sale, Tuesday, May 12th to 16th, five days of special low priced sales in every department.

HUTSONS

325-331 Eighth Avenue

Homestead, Pa

This Space is for the Address Only

Mrs. Lenora Shawl
Duquesne Ave.
Homeville Pa.

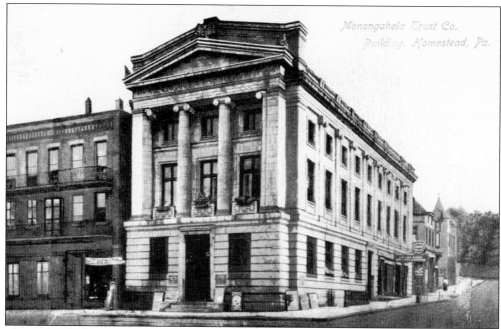

The Monongahela Trust Company of Homestead was located on East Eighth Avenue and Ann Street in this massive Georgian-style building. When the firm constructed its new building at the corner of Amity Street, the First Slovak Savings and Trust Company bought the old one for its new headquarters.

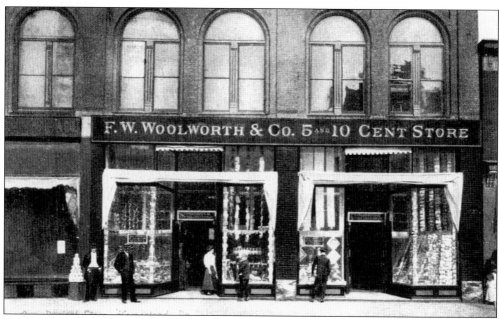

The F. W. Woolworth store stood on East Eighth Avenue in 1911. Today the site is the home of Levine Hardware.

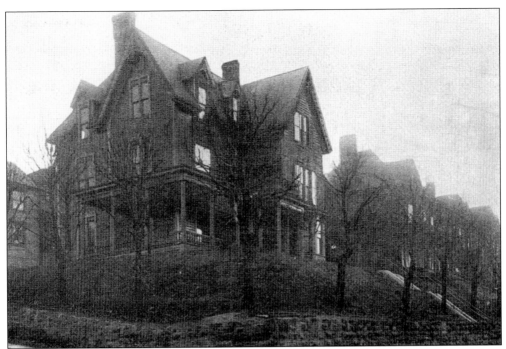

The first Homestead Hospital, seen in the above real photo postcard from 1911, was located at the corner of Hays Street and East Ninth Avenue on the Homestead–West Homestead border. The 1930s postcard below shows the new Homestead Hospital that was built on West Street. The spot has since become an elder nursing home and various professional offices.

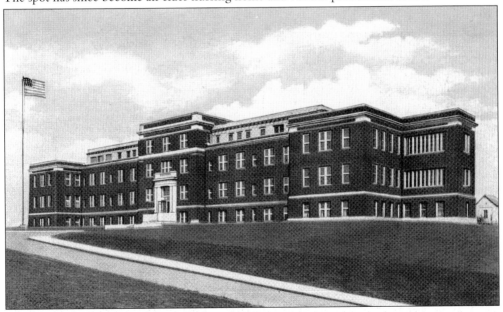

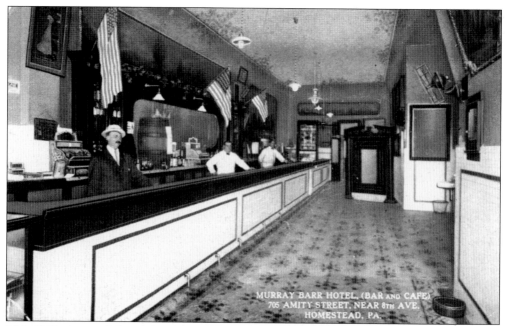

This 1920s postcard shows the owner and bartenders of the Murray Bar Hotel, situated at 705 Amity Street in Homestead. At one time, Homestead had more drinking establishments than any other municipality.

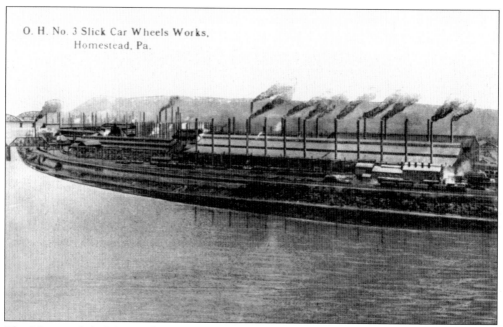

The Monongahela River reflects Open Hearth No. 3 and the Slick Car Wheel Works in this 1920s postcard.

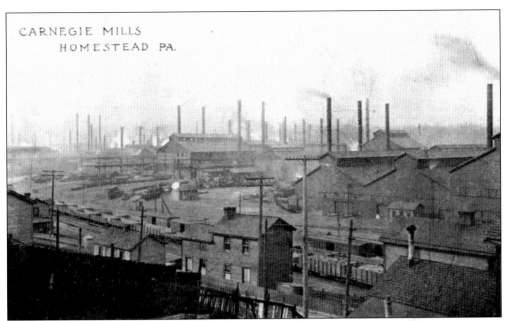

The Carnegie mills and the open hearths are viewed from the Munhall Junction area. Although known as the Homestead Steel Works, 75 percent of the mill proper was actually located in the borough of Munhall. The postcard above dates to 1905, and the one below is from 1910.

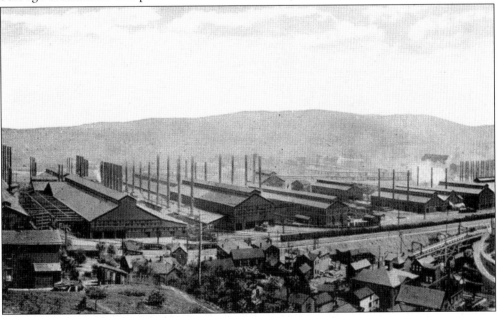

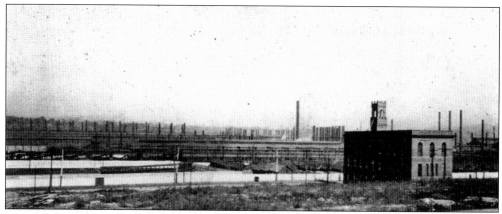

The Homestead Steel Works open hearths are visible in the distance in this 1905 postcard published by the *News-Messenger*. On the left are the Homestead Library Athletic Club fields. In the center are the houses of Potterville owned by the Carnegie Steel Company. To the right is the newly constructed Munhall Municipal Building at the corner of Andrew Street and Eighth Avenue. The whitewashed fence from the 1892 steel strike still surrounds the perimeter of the mill. This view is from Tenth Avenue.

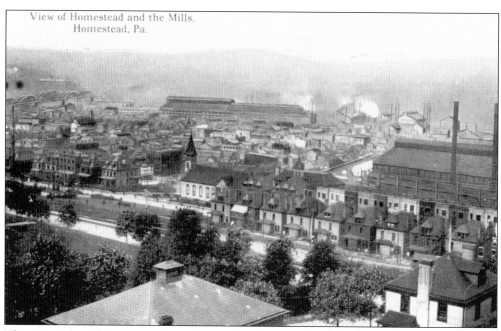

This view was likely taken from the roof of the old Munhall Public School about 1905. St. Michael's Slavish Roman Catholic Church appears in the center. In the distance are Open Hearth No. 3 and the Slick Car Wheel Works. The row houses are located on Ninth Avenue in Munhall.

A Fogg painting was made into this 1950s postcard, which shows the mills of the Homestead District Works of the U.S. Steel Corporation. These mills surrounded the main line of the Pittsburgh and Lake Erie Railroad Company.

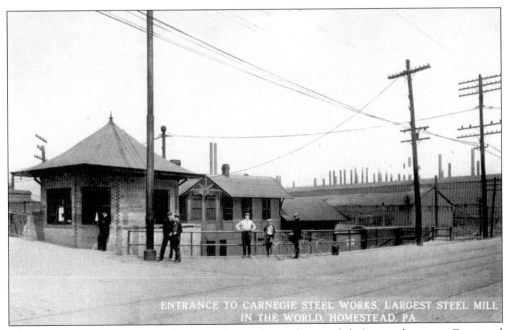

ENTRANCE TO CARNEGIE STEEL WORKS, LARGEST STEEL MILL IN THE WORLD, HOMESTEAD, PA.

This entrance to the Carnegie Steel Works was located on Eighth Avenue between Grant and Harrison Streets in Munhall. It provided employees with safe entry over the railroad tracks.

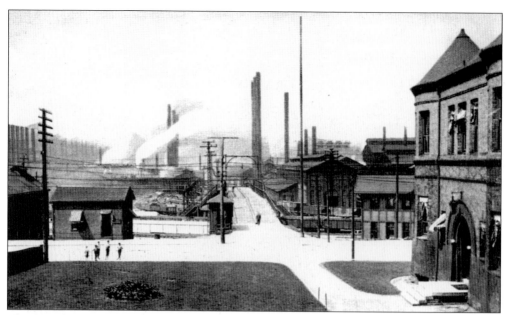

The Grant Street entrance to the Carnegie Steel Works was directly across from the company offices.

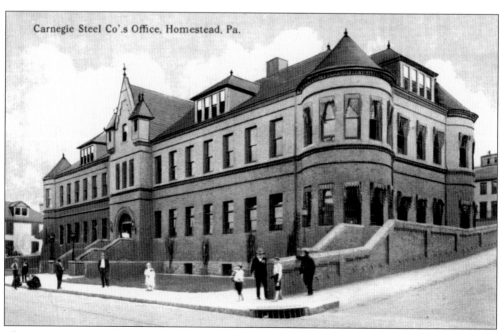

Carnegie Steel Co'.s Office, Homestead, Pa.

The Carnegie Steel Company's office building, located on Eighth Avenue between Grant and Harrison Streets, provided office space for the various departments of the mill. The structure was destroyed in a fire in 1944.

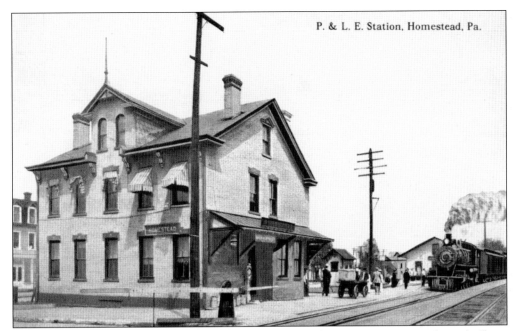

Seen here in 1912, the Pittsburgh and Lake Erie Railroad station in Homestead was built on Sixth Avenue and Ann Street in the 1890s. This building was demolished in 1943 for a more modern station.

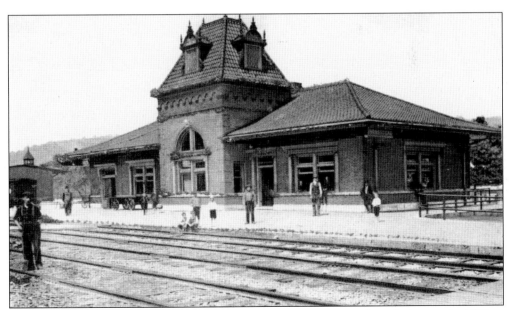

The Pennsylvania Railroad built a new station at Amity Street and Sixth Avenue in 1908 to handle its expanding business in the Homestead area. This postcard dates to 1912.

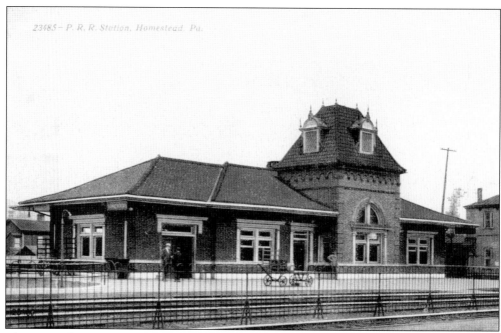

The Pennsylvania Railroad station was a main transportation hub for the Homestead area throughout its years. During World Wars I and II, many of the draftees left from this station after being given a send-off in a grand parade. Today the building has been restored to its original grandeur and houses professional offices. Both postcards date from the 1920s.

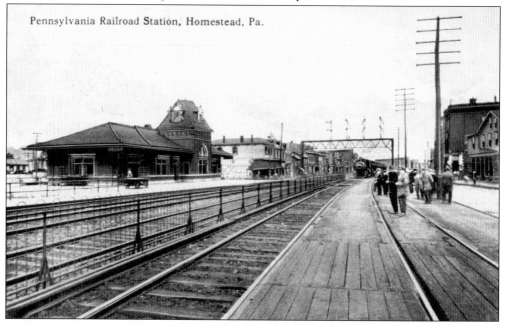

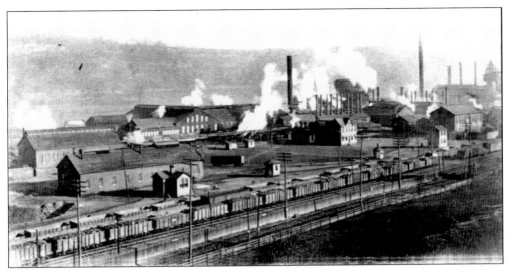

This eastward view depicts the Duquesne Steel Works in 1902. The Carnegie Steel Company purchased these works from the Allegheny Bessemer Steel Company in 1889.

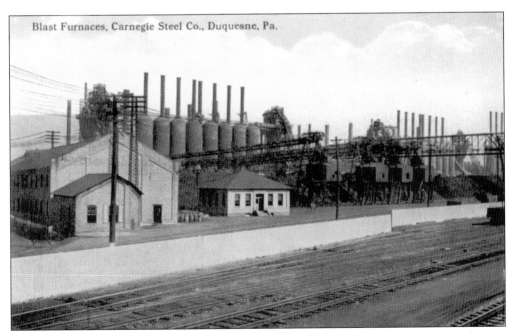

Blast Furnaces, Carnegie Steel Co., Duquesne, Pa.

The blast furnaces of the Duquesne Steel Works are seen from South Duquesne Avenue in 1905.

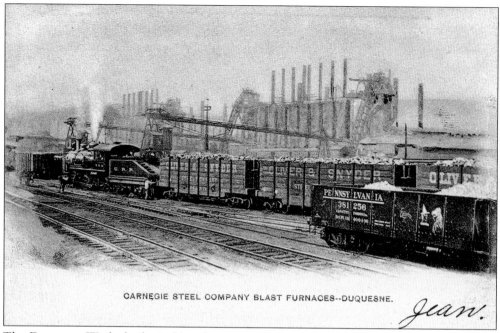

CARNEGIE STEEL COMPANY BLAST FURNACES--DUQUESNE.

Jean.

The Duquesne Works built six blast furnaces between 1896 and 1897. The above postcard, dated 1904, shows the massive rail yards. In the 1912 postcard below, the sender states, "I helped erect these."

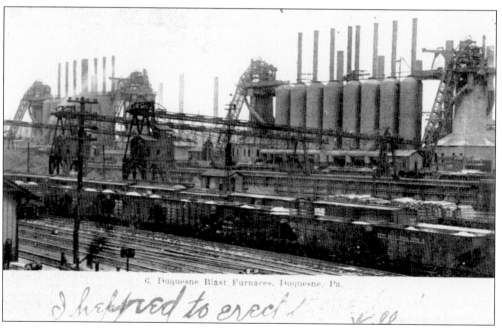

6. Duquesne Blast Furnaces, Duquesne, Pa.

I helped to erect

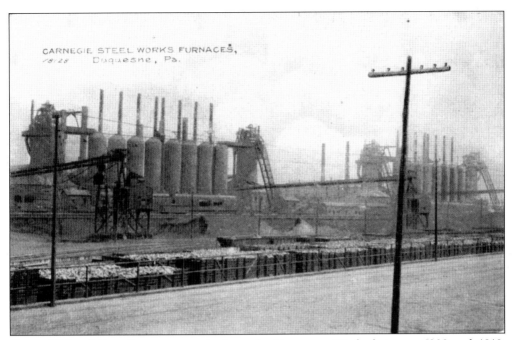

Two additional blast furnaces were built at the Duquesne Works between 1909 and 1910. The maximum monthly production at that time was 102,057 tons. After the ore yards were connected, they handled 1,108,125 tons of ore, limestone, and coke. These postcards are dated 1910 (above) and 1918 (below).

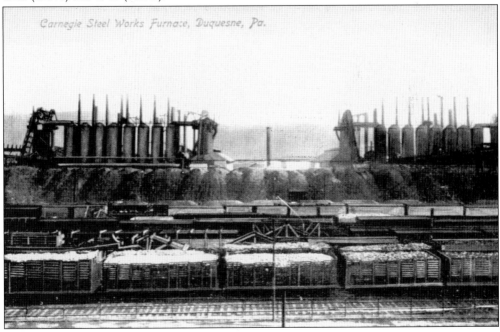

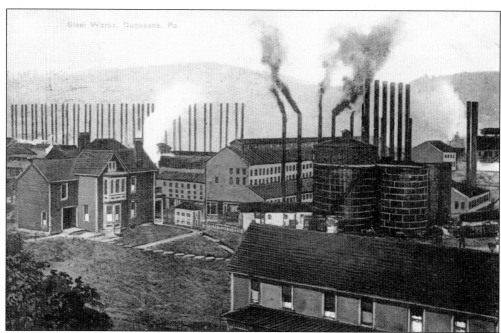

The Duquesne Steel Works open hearths are shown in the 1910 postcard above and 1925 postcard below. At this time, the open hearth department had fourteen 50-ton, six 60-ton, and twelve 75-ton furnaces, with a maximum total monthly production of 147,610 tons. In 1916, a new 20-ton electric furnace was in the process of being built. These views look north from the Camp Avenue area. In the postcard below, the Duquesne Builder's Supply Company stands to the left.

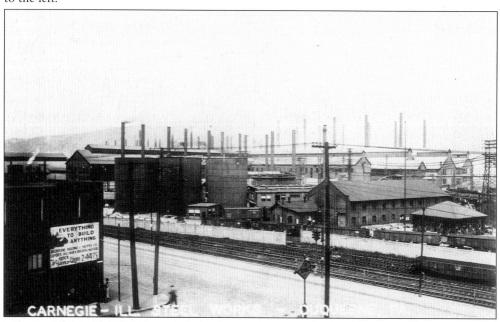

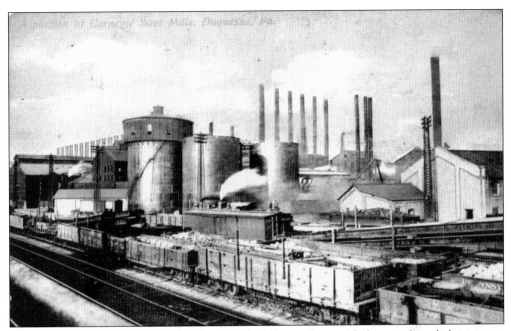

The massive Duquesne Works water-storage tanks appear along with the open hearth department and rail yards in this 1920s postcard.

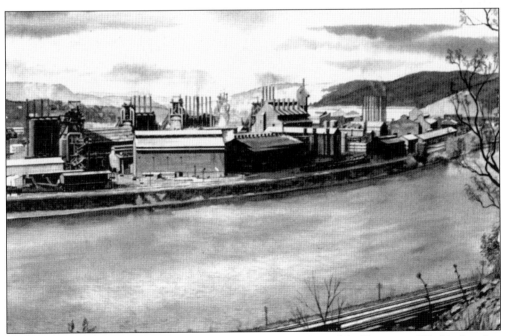

This Fogg postcard from the 1950s provides a panoramic view of the Duquesne Works, showing the blast furnaces and open hearths from across the river.

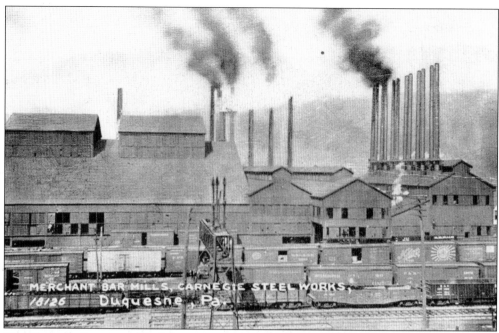

The Carnegie Duquesne Works' No. 2 mill produced a monthly 16,080 tons; its No. 1 mill produced 13,749 tons; its No. 4 produced 4,328 tons; its No. 3 produced 2,823 tons, its No. 5 produced 15,854 tons; and its No. 6 produced 20,427 in 1916. The 1915 postcard above shows the mill, and in the below postcard, the bar mill is shown with the Oliver railway station.

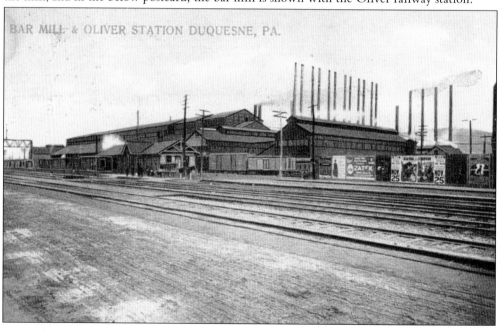

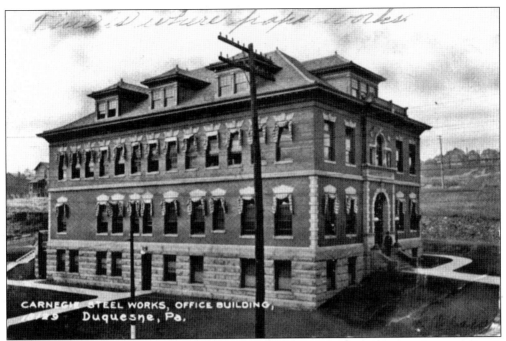

The Carnegie Steel Works office building in Duquesne, located at Library Place and South Duquesne Avenue, appears in this 1910 postcard view from South Duquesne Avenue. The building housed the offices of the general superintendent, along with an employment office. These postcards predate the well-known concrete walkover to the left of the present building. The sender even noted that "this is where papa works" on the face of the card. In the 1920s postcard below, the structure is viewed from the Whitfield Street side.

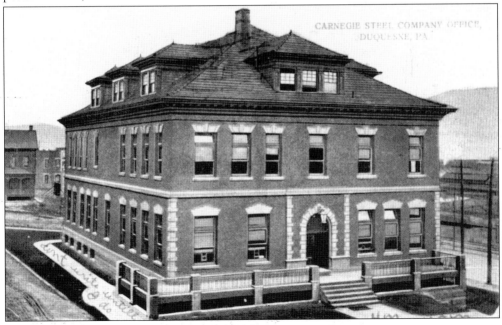

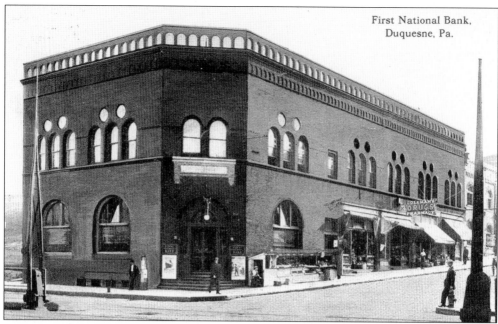

First National Bank,
Duquesne, Pa.

The First National Bank of Duquesne was established in the 1890s by the Crawford family and a group of investors. The landmark building stood on the corner of West Grant and South Duquesne Avenues. The above 1905 postcard view looks up West Grant Avenue and toward the Coleman Pharmacy, with the awning. Through the years, the building was remodeled, as shown in the 1940s postcard below. It was demolished in the 1950s for urban and highway development.

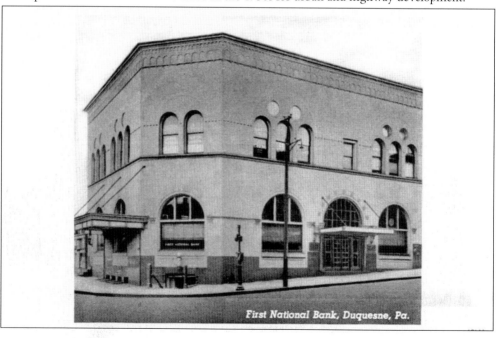

First National Bank, Duquesne, Pa.

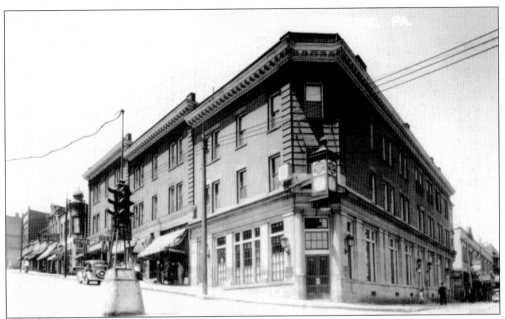

The Duquesne Trust Company was located at West Grant Avenue and First Street; it was then known as the Duquesne City Bank before merging with other institutions. The landmark building was known for its clock, which hung over the main entrance at the corner. To the left are the Benkowitz Shoe Store and Eagle's Drug Store, and to the right are Woody's Drug Store and the Plaza Theatre, which included professional offices on the second floor. This postcard dates to the 1940s.

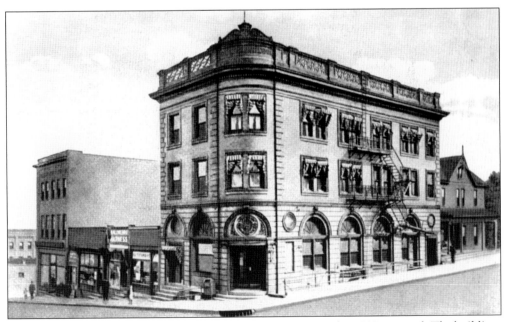

The Monongahela Valley Trust Company building is shown in this 1910 postcard. The building, at the corner of West Grant Avenue and South Second Street, is a well-known Duquesne landmark. At one time, it also served as the post office.

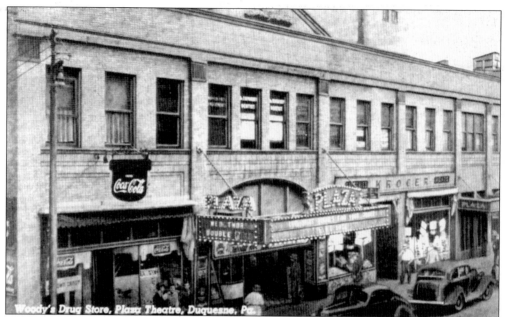

The Plaza building stood on North First Street in Duquesne. This 1940s postcard shows Woody's Drug Store, the Plaza Theatre entrance, and the Kroger food store. The building was razed in the late 1950s for urban redevelopment. Today a small shopping complex occupies this area.

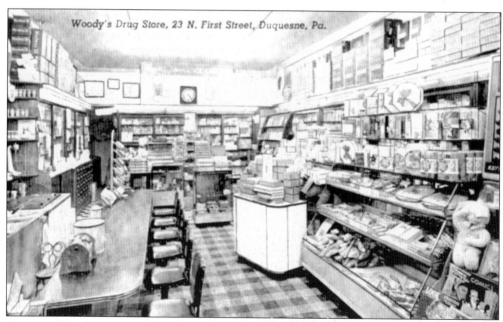

Many residents remember Woody's Drug Store, located on North First Street in the Plaza Theatre building. The drugstore, seen here in the 1940s, included fountain service with drinks and ice cream for those wishing to indulge. As any drugstore of that time, it sold the area's famous Tris-Anne chocolates, which were produced in McKeesport. Although the building was demolished in the 1960s redevelopment, Woody's relocated to a shopping complex in West Mifflin. The store went out of business in the late 1980s.

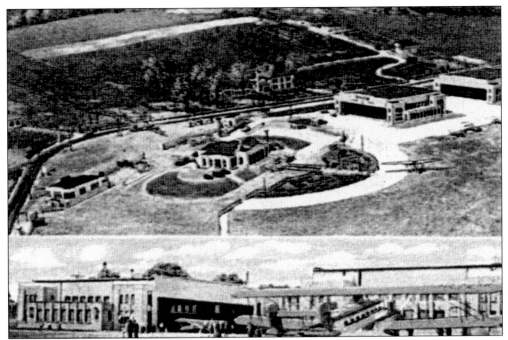

The Pittsburgh-McKeesport Airport, known as the Bettis Airport, appears in this 1930s aerial view. It was Pittsburgh's first commercial airport when the aviation era began. Many people were amazed with the stunning air shows given there in its heyday. Although the airport was in the original Mifflin Township (today's West Mifflin), it was associated with the Dravosburg area. The airport closed in the late 1940s and was bought by Westinghouse Electric Corporation. Today the site houses the Bettis-Bechtel Laboratories, specializing in nuclear energy power plants.

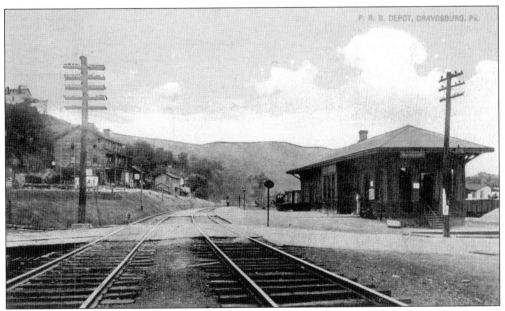

The transportation hub for the Dravosburg area, the Pennsylvania Railroad station was located on McClure Street and was razed in the 1970s.

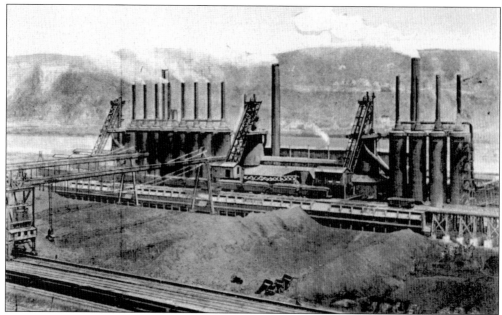

The Clairton Steel Works blast furnaces are pictured above in a 1920s postcard. The steel mills, spanning 175 acres and stretching along two miles of river, were originally formed as the St. Clair Steel Company. In 1902, Crucible Steel bought the firm and renamed it the Clairton Steel Company. The Carnegie Steel Company then purchased it in 1904. The view below, also from the 1920s, shows the open hearths of the steelworks. After World War II, the mill was converted to produce coke for the mills along the valley.

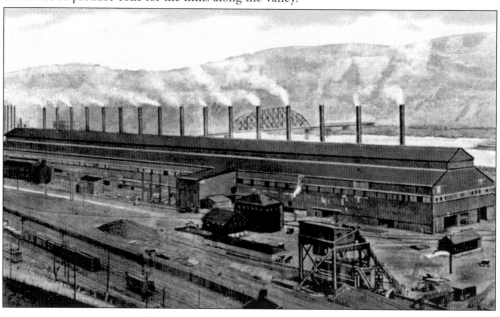

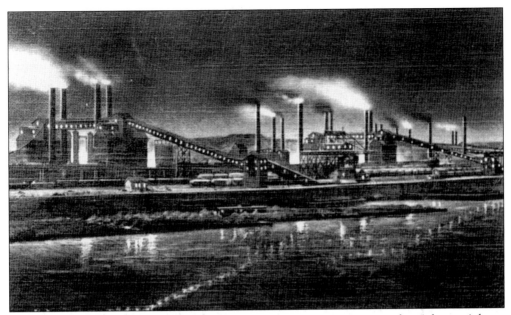

The Clairton Coke Works plant, pictured in the 1940s, was a spectacular sight at night to motorists on the road alongside the opposite side of the river.

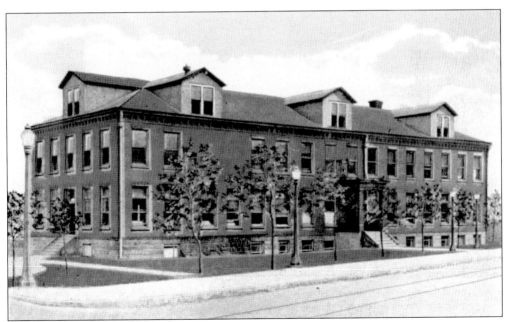

Shown in this 1920s postcard, the Clairton Steel Works offices are located on State Street (Route 837) in a large and stately building.

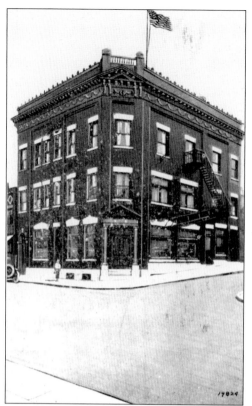

The First National Bank of Wilson, pictured in the 1915 postcard to the left, was located on State Street and Walnut Avenue in the Wilson District of Clairton and opened on June 1, 1903. Its name was later changed to the First National Bank of Clairton when Clairton was incorporated as a city. The Union Trust Company of Clairton, shown below, stood at St. Clair Street and Miller Avenue. In 1942, the First National Bank of Clairton purchased the bank and made this its main office. Today it is the home of the National City Bank.

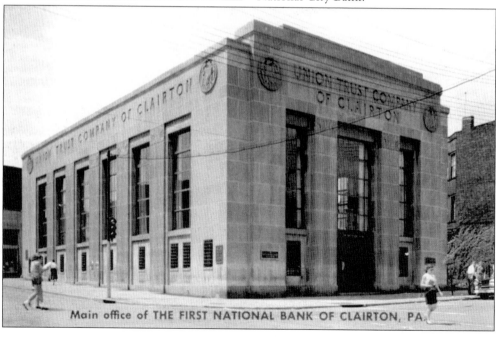

Main office of THE FIRST NATIONAL BANK OF CLAIRTON, PA.

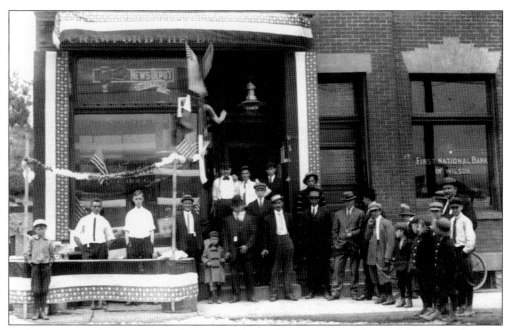

In this *c.* 1910 real photo postcard, a group of good friends poses in front of the Crawford Drug Store on State Street near Walnut Avenue, adjacent to the First National Bank of Wilson.

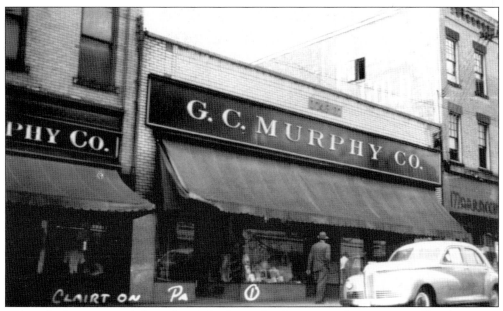

This real photo postcard from the 1940s shows the G. C. Murphy store on Miller Avenue in Clairton. Next door was Marraccini's Market, an established business known for its fine meats.

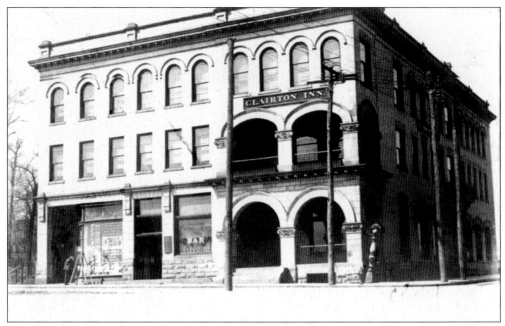

The Clairton Inn, seen in the above real photo postcard from 1910, opened on the corner of St. Clair Street and Miller Avenue on January 1, 1903. The proprietor was J. B. Lyons. Upon its opening, the inn became one of the most magnificently furnished and modernly equipped hotels in western Pennsylvania. It contained 60 artistic mahogany, iron, and oak furnished rooms, illuminated by electricity and heated by steam. The postcard below dates from the 1920s.

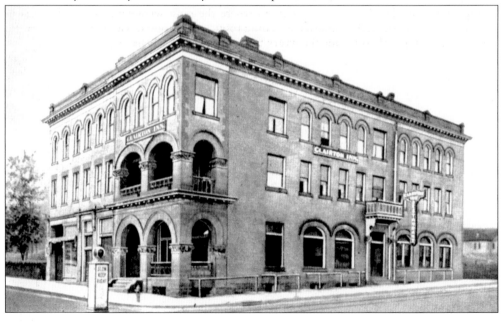

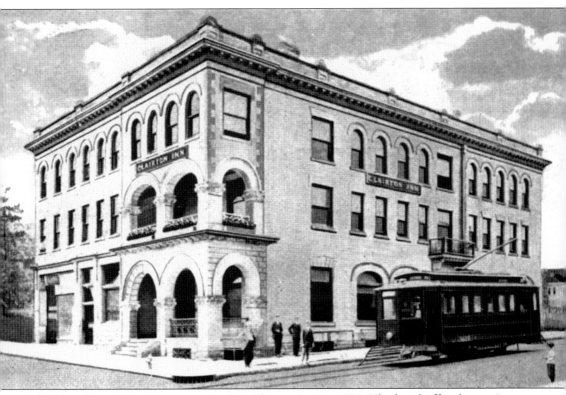

A Clairton Electric Railway car passes the Clairton Inn in 1915. The hotel offered a spacious dining room with liveried service, a kitchen where the most wholesome to the daintiest of delicacies were prepared. A comfortable reading room, a bar stocked with the best liquors and cigars, and a congenial host made the weary traveling man feel at ease.

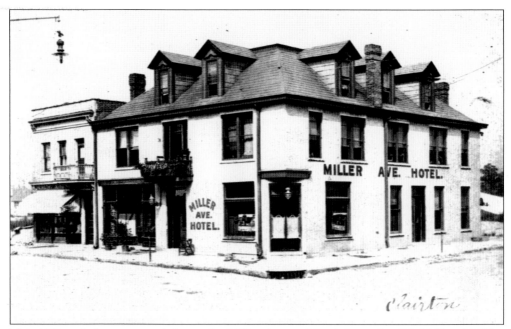

This 1910 real photo postcard shows the Miller Avenue Hotel, located at Waddell and Miller Avenues in Clairton.

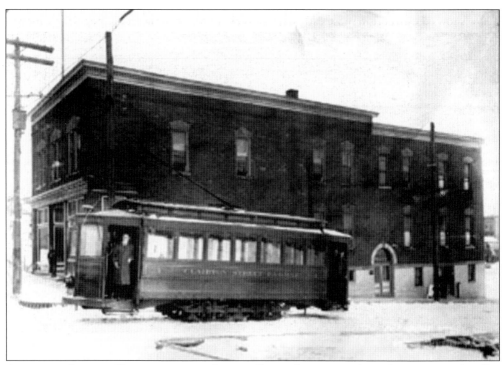

A passenger leaves a Clairton Street Railway trolley at the corner of St. Clair Street and Miller Avenue in this 1908 real photo postcard. The building is where the Clairton Post Office was located at that time. Clairton Hardware also operated there.

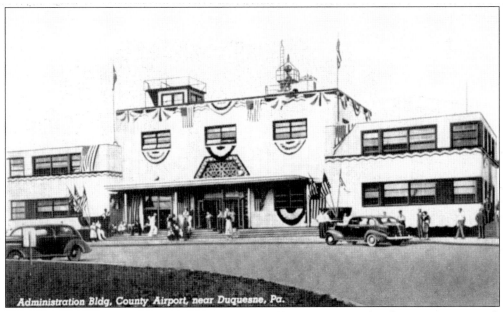

Administration Bldg, County Airport, near Duquesne, Pa.

The Allegheny County Airport administration building appears in the above 1940s postcard. Plans were prepared to build a new airport for Pittsburgh in the late 1920s, and the Allegheny County commissioners selected an area in Mifflin Township. When the airport was dedicated on September 11, 1931, it was the longest hard-surface runway. No buildings were constructed. Within the next two years, five structures were built (and still stand today). The aerial view below shows the airport in those early days, possibly crowded for one of its popular air shows.

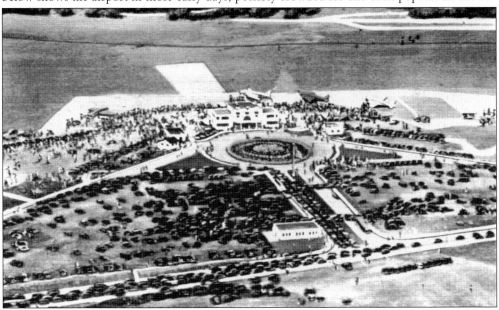

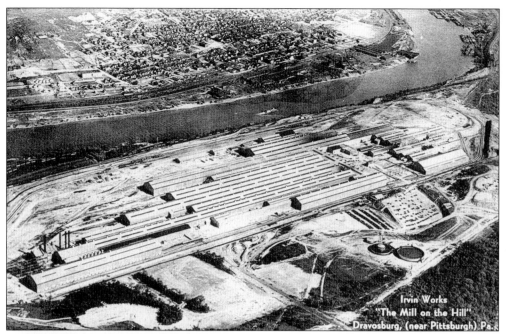

Irvin Works
"The Mill on the Hill"
Dravosburg, (near Pittsburgh) Pa.

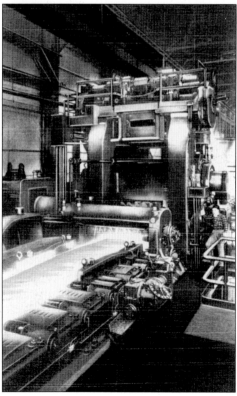

The U.S. Steel Irvin Works plant in West Mifflin was aptly named "the Mill on the Hill." The Mesta Machine Company designed and built the mill, which opened in 1938. By the 1950s, it was known as the greatest hot-strip mill in the country. The above real photo postcard shows the mill about 1940. To the left, a hot-strip roller is pictured in the 1940s.

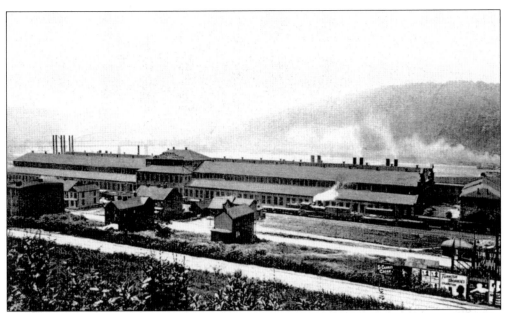

The Mesta Machine Company began business on December 1, 1898, as a consolidation of the Leechburg Foundry and Machine Company of Leechburg and the Robinson-Rea Manufacturing Company of Pittsburgh. The plant started with two 60-foot buildings and one 40-foot wedge step steel building. The postcard above, dating to 1912, shows the view from Doyle Avenue. The 1915 postcard below depicts East Seventh Avenue and the plant in West Homestead.

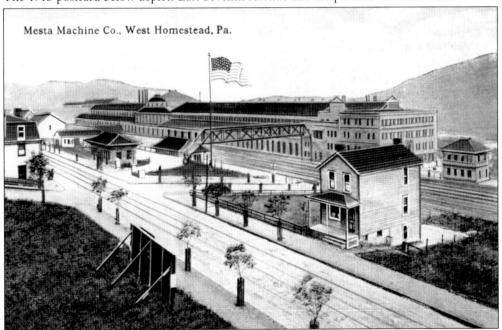

Mesta Machine Co., West Homestead, Pa.

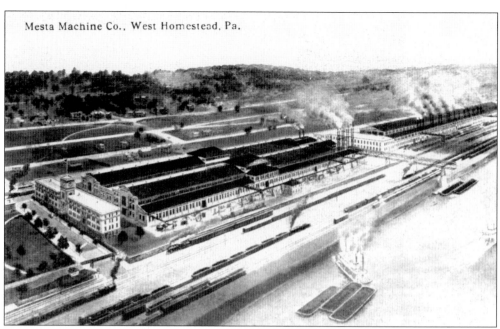

Mesta Machine Co., West Homestead, Pa.

In 1901, a main office building was constructed, and by 1903, the Mesta Machine Company had acquired the much needed land for expansion. In fact, the firm had provided the knowledge and skill behind the designing and building of many industrial mills and power plants in the country from its inception. By the 1980s, however, it was closed. The above panoramic aerial view shows the plant about 1912, and the below view depicts the offices across the Pennsylvania Railroad tracks.

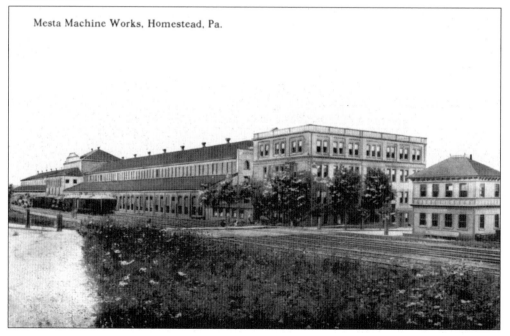

Mesta Machine Works, Homestead, Pa.

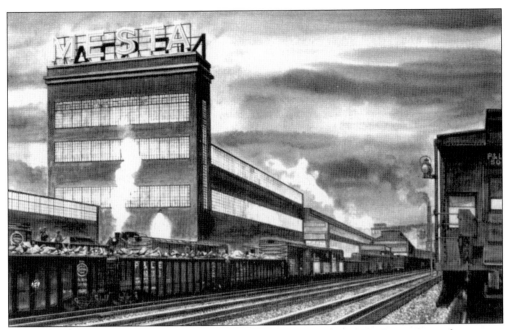

The Mesta Machine Company displays its landmark sign in this 1950s Fogg postcard.

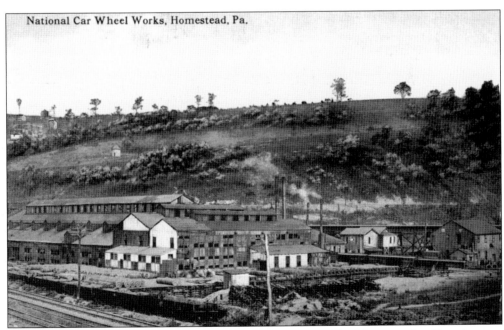

The National Car Wheel Works was located along the river in West Homestead and later became the Howard Axle Works of the Carnegie Steel Company. The works stood until 1942.

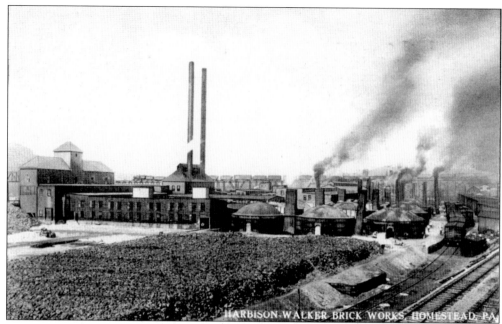

The Harbison Walker Brick Works in West Homestead, shown in 1920, produced refractory bricks for the linings of blast and open hearths, coke ovens, and boilers. The plant was located near the present-day Sand Castle and Glenwood Bridge.

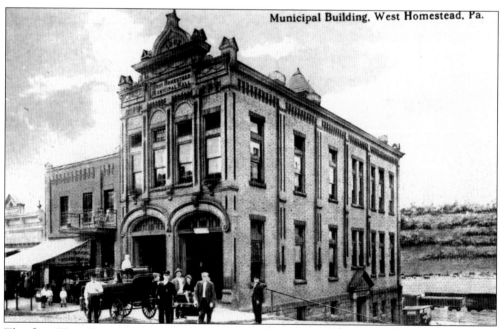

The first West Homestead Municipal Building was built on West Eighth Avenue in 1902. Pictured in this 1910 postcard, the structure contained the municipal offices, police department with jail, fire department, and council chambers.

Three

Churches, Schools, and Institutions

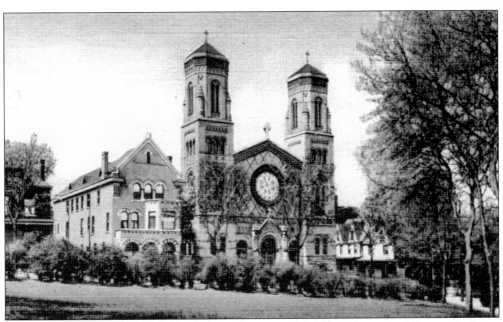

Founded in 1880, St. Mary Magdalene Roman Catholic Church in Homestead was one of the largest Irish Catholic churches in the area. This view from Frick Park shows the Amity Street church in the 1940s. The present-day building was constructed in 1896. A major fire in 1932 destroyed much of the structure, and when it was reconstructed it lost its impressive steeples.

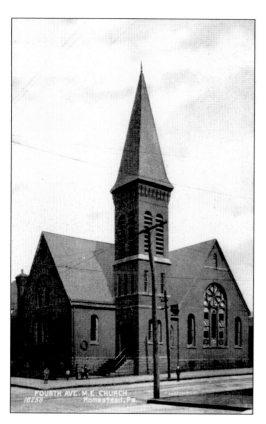

The Fourth Avenue Methodist Episcopal Church was located on Fourth Avenue in the First Ward of Homestead. The building was razed during the demolition of the ward in 1941.

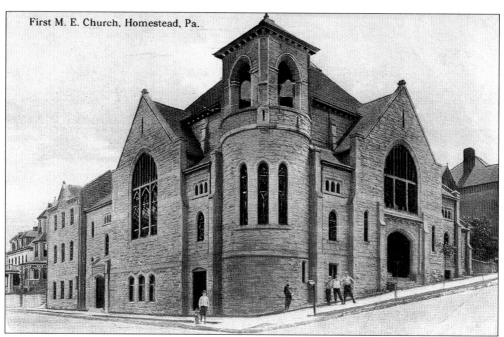

The First Methodist Episcopal Church of Homestead, seen here in the 1920s, stands at East Tenth Avenue and Ann Street.

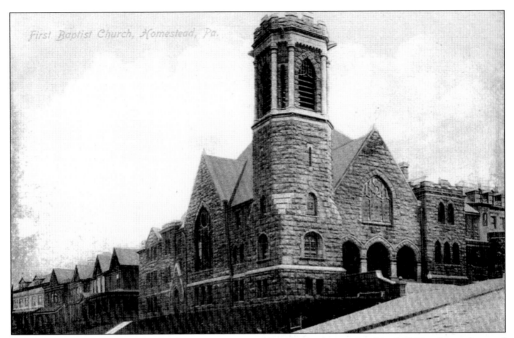

Shown in this 1920s postcard, the First Baptist Church was organized in 1883 and constructed at East Ninth Avenue and McClure Street in Homestead.

The St. Francis Roman Catholic Church was located on the corner of Ninth Avenue and McClure Street. The building was razed when the congregation merged with other local churches.

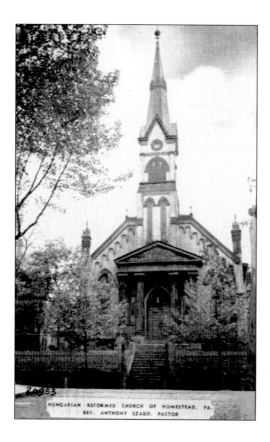

The First Hungarian Reformed Church on Tenth Avenue is pictured in this rare 1950s postcard.

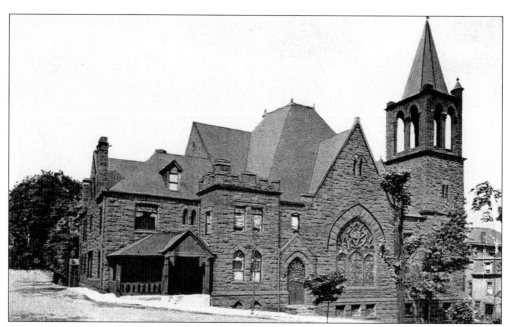

The First Presbyterian Church of Homestead, appearing here in the 1930s, is located at East Ninth Avenue and Ann Street.

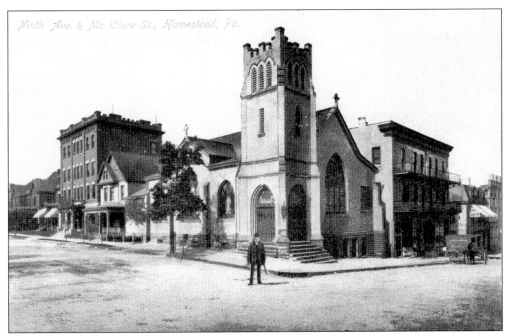

In this 1904 postcard, St. Mark's Church is pictured at the corner of East Ninth Avenue and McClure Street. The building later became the first home of the St. Elias Byzantine Catholic Church. The tall structure to the left is the Odd Fellows building.

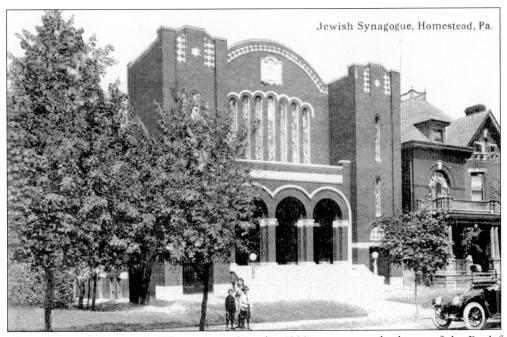

This East Tenth Avenue building, pictured in the 1920s, was once the home of the Rodef Shalom Synagogue in Homestead. Today it is the home of the Church of the Crucified One.

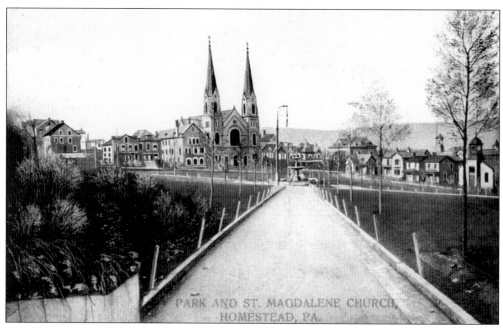

The St. Mary Magdalene Roman Catholic Church is pictured with its steeples in this 1920s view from Frick Park.

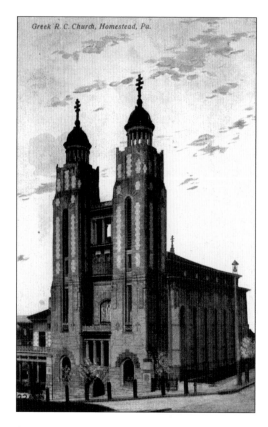

St. John the Baptist Cathedral, pictured in 1915, is located at the corner of Dickson Street and Tenth Avenue. Today it is vacant and awaits restoration.

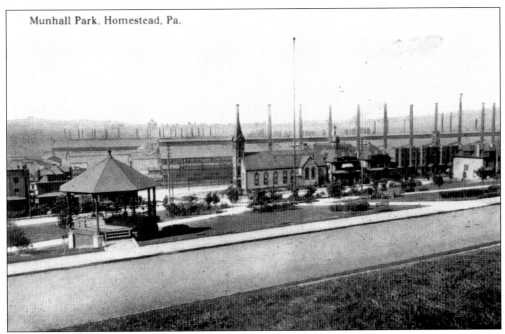

Munhall Park, Homestead, Pa.

The St. Michael Salvish Roman Catholic Church began "below the tracks" in 1897 and, by the early 1900s, had erected a church on Library Street, as seen in the 1910 view above. The new St. Michael's Church, shown in the 1960s chrome color postcard below, subsequently replaced this older structure.

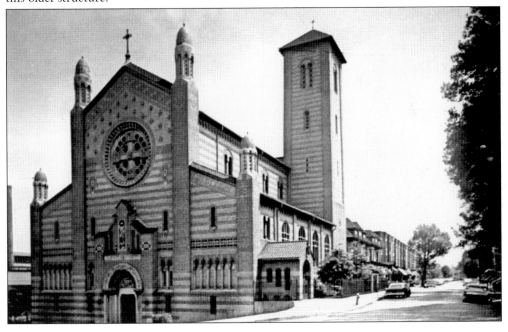

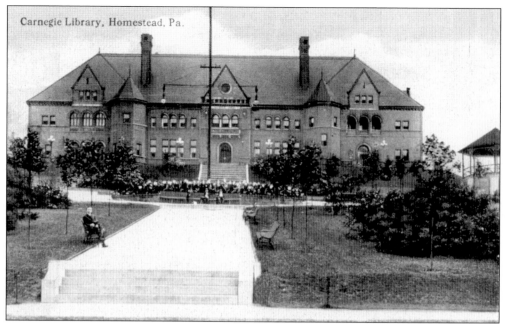

Carnegie Library, Homestead, Pa.

Located on Tenth Avenue in Munhall, the Carnegie Library of Homestead was built with funds donated by Andrew Carnegie. Carnegie's second library, it opened with a grand dedication in 1898. Today the building is registered as a National Historic Landmark, and through the years funding has been acquired for its restoration. Both postcards date from about 1912.

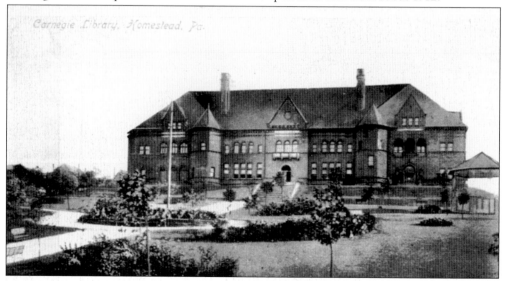

Carnegie Library, Homestead, Pa.

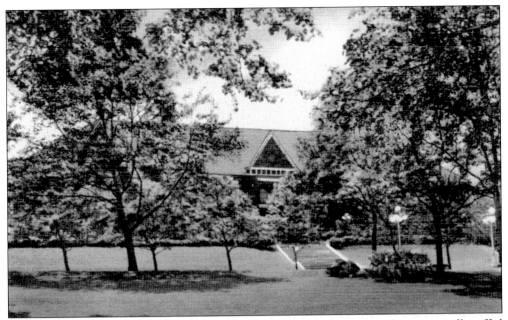

The Carnegie Library of Homestead contains a music hall with an original organ, a well-staffed library, an athletic club, and an indoor swimming pool. Thousands have used its facilities throughout its more than 100 years of operation. Many have learned to swim in the Carnegie pool, also known for its famous Olympic swim teams during the 1920s and 1930s. Above is a 1940s postcard, while below is a 1950s chrome color card.

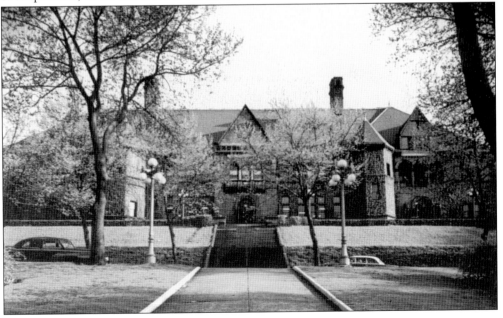

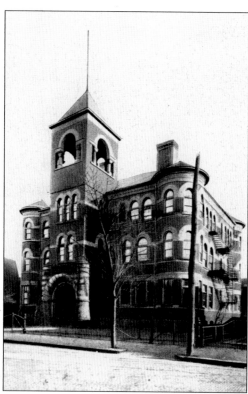

The first Homestead High School, shown here in 1905, was located on Fourth Avenue.

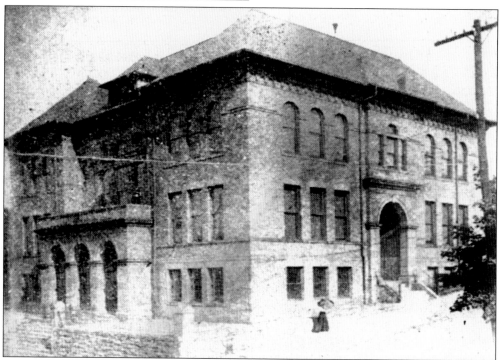

The Fifth Ward Elementary School in Homestead, pictured in this *Daily Messenger* postcard of 1905, was located at West Street and East Eleventh Avenue.

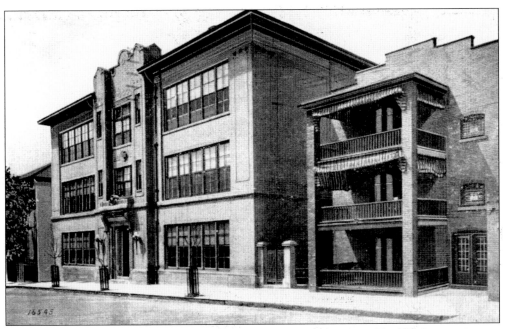

Homestead's new junior high school, seen in the 1920s, stood on East Twelfth Avenue.

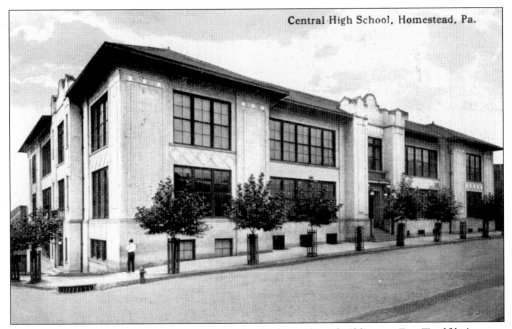

Central High School, Homestead, Pa.

In this 1920s postcard, the new central high school is housed in a building on East Twelfth Avenue. Today the structure contains the Barrett Elementary School of the Steel Valley School District.

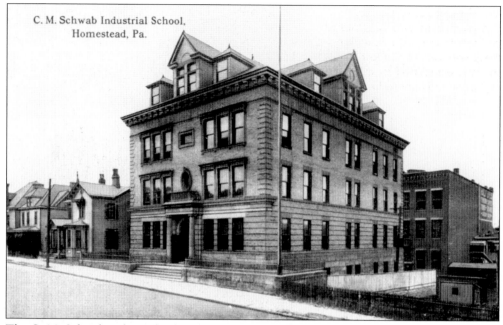

C. M. Schwab Industrial School,
Homestead, Pa.

The C. M. Schwab Industrial School, appearing here in 1910, was built on East Ninth Avenue with money donated by Charles Schwab, superintendent of the Homestead Works. The building stands today, though vacant.

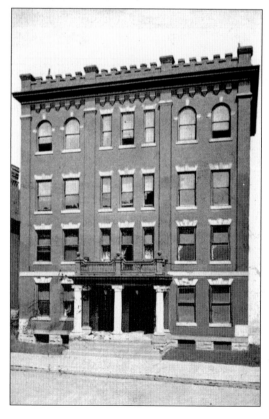

The Odd Fellows building, pictured in 1910, was located on Ninth Avenue in Homestead. Today it is a newly renovated apartment complex.

The new Turner Hall, shown on a postcard from 1905, was located on Fifth Avenue. This building, along with others, was lost during the 1941 demolition for mill expansion in Homestead.

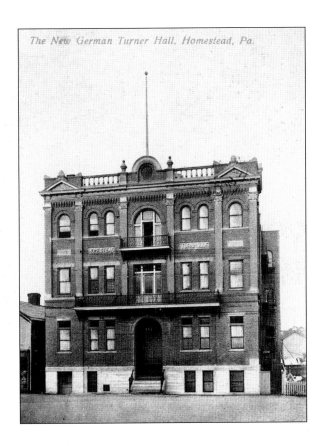

The Masonic Hall of Homestead, seen here in the 1930s, is located at East Ninth Avenue and McClure Street. Today the structure houses professional offices.

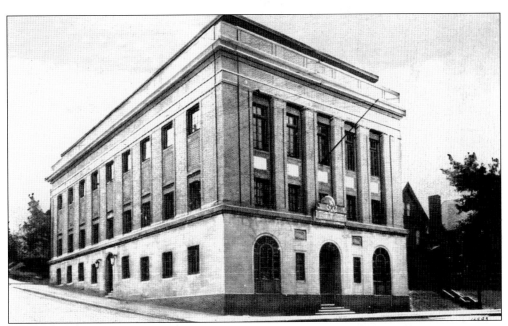

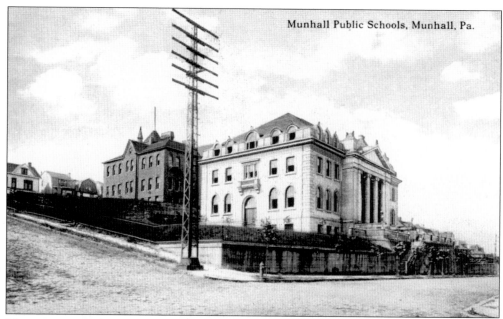

These postcards depict Munhall public schools, located on Eleventh Avenue, about 1910. The red-brick building to the rear was the original Mifflin Township Elementary School, constructed in 1893 at a cost of $22,268. The white structure, built around 1904, became the high school for Munhall. As the years progressed, additions were completed to this original building. In the 1970s, it was demolished when Munhall, Homestead, and West Homestead merged as the Steel Valley School District. Today it is a vacant lot. Both postcards date from the second decade of the 20th century.

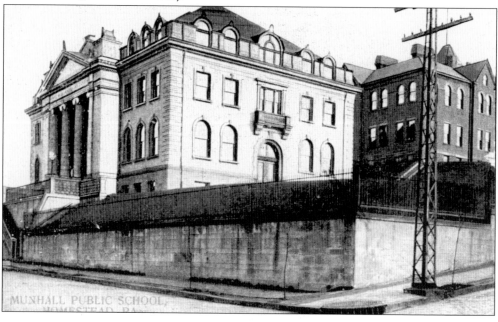

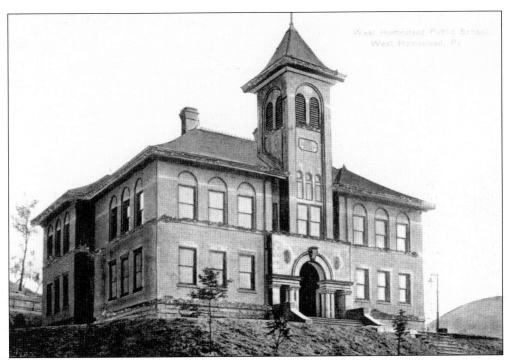

The West Homestead Public School, located on Walnut Street, was rebuilt in 1903 after fire destroyed the first building. This postcard dates from 1910. Today the building houses a business.

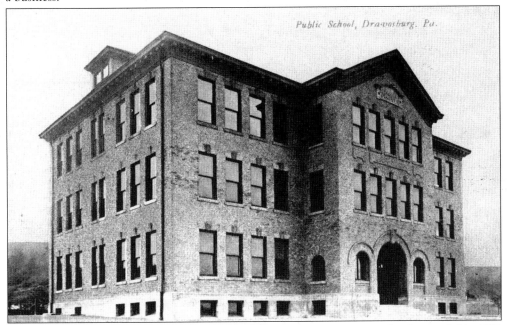

The Third Street School in Dravosburg, built in the early 1900s, is the focus of this 1910 postcard. With dwindling enrollment and the merge with the McKeesport Area School District, this school was no longer needed. For a while, it served as a municipal building and senior center before being razed.

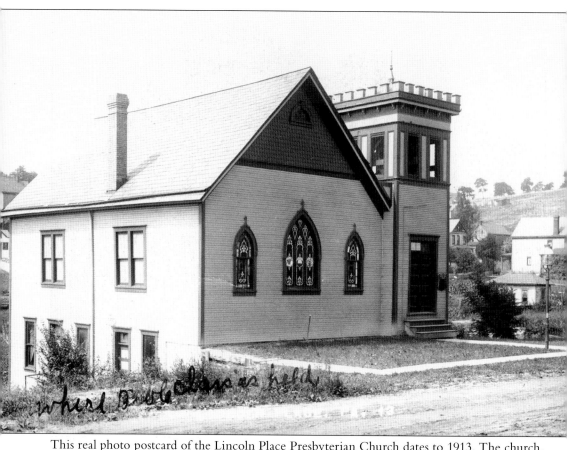

This real photo postcard of the Lincoln Place Presbyterian Church dates to 1913. The church, located on Muldowney Avenue, was replaced with a modern brick structure in the 1960s.

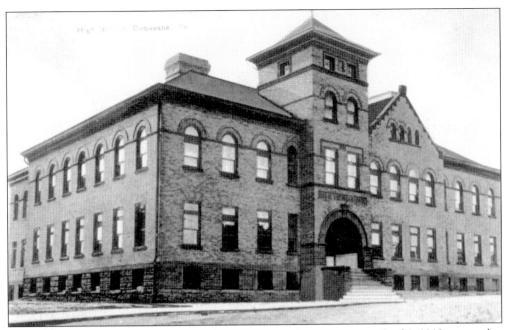

The first high school in Duquesne stood on South Sixth Street, as seen in this 1912 postcard.

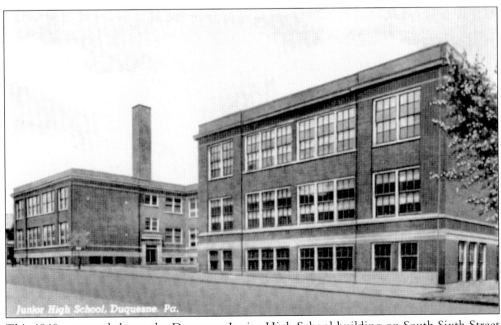

This 1940s postcard shows the Duquesne Junior High School building on South Sixth Street that replaced the old high school above.

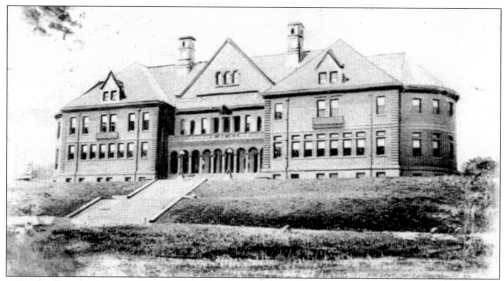

The Carnegie Library of Duquesne was the third such structure built with a donation from Andrew Carnegie. Construction started in 1901 on South Second Street at Library Place between Kennedy and Whitfield Avenues, and the building was dedicated in November 1904. The postcard above dates to 1908, and the one below is from 1910.

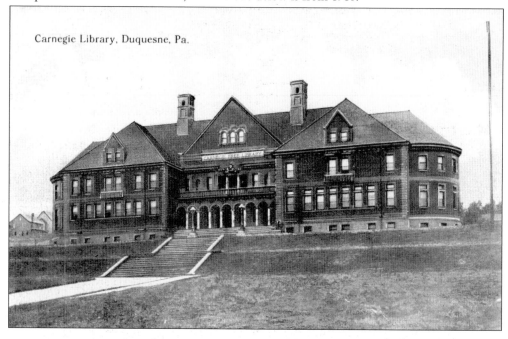

Carnegie Library, Duquesne, Pa.

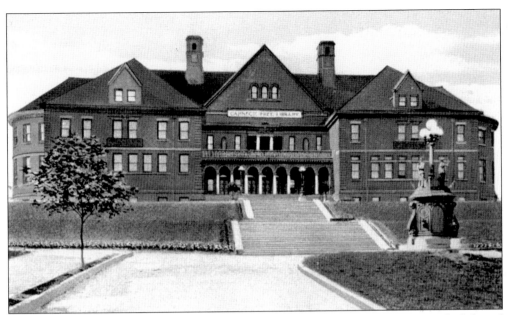

The Carnegie Library of Duquesne featured a music hall in the center, a library to the left, and an athletic club, billiard room, and indoor swimming pool to the right. The building was razed in 1968. Today homes have been constructed on the grounds. The postcard above dates to the 1930s, and the one below is from 1940.

Carnegie Free Library, Duquesne, Pa.

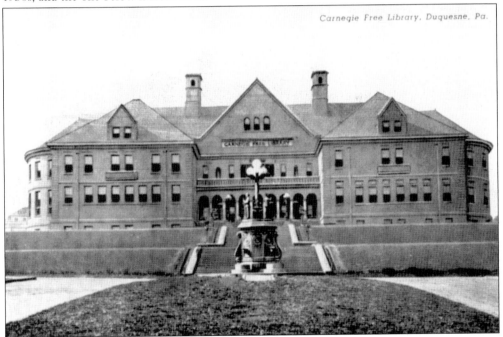

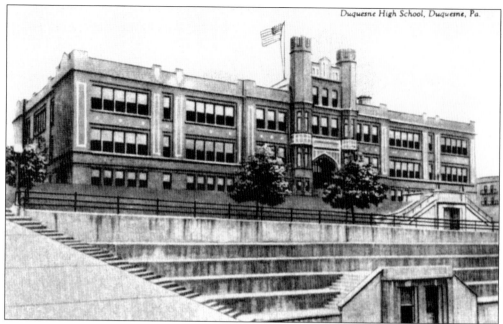

Duquesne High School, Duquesne, Pa.

Duquesne High School was constructed on South Fourth Street between Kennedy and West Grant Avenues in 1913. Remodeled in the 1990s, it now houses kindergarten through 12th-grade students in the Duquesne School District. The postcard above dates to the 1920s. The view below shows the building from the veterans park.

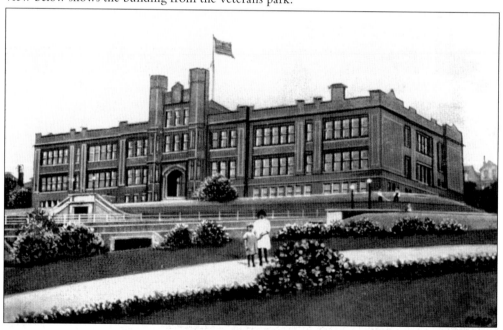

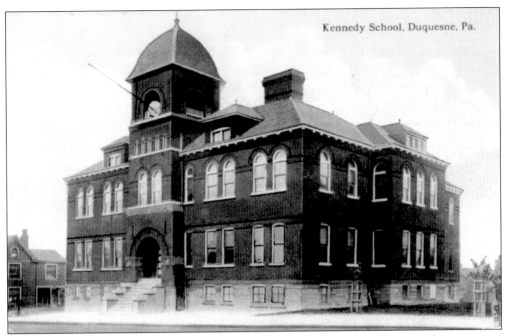

In 1892, Kennedy School was built on South Sixth Street at a cost of $22,000. The contractor was Donald Stratton of McKeesport. The school is seen here in 1912. Today the building is renovated as a senior retirement home.

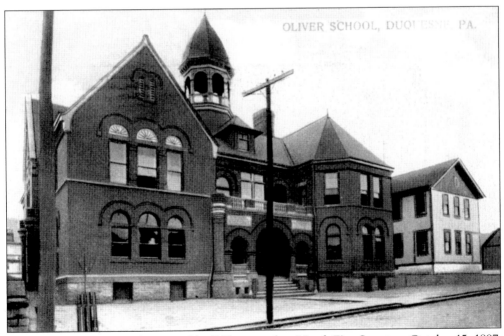

OLIVER SCHOOL, DUQUESNE PA.

The second Oliver School, pictured in 1912, opened on North First Street on October 15, 1897. Today a senior retirement complex stands on this property.

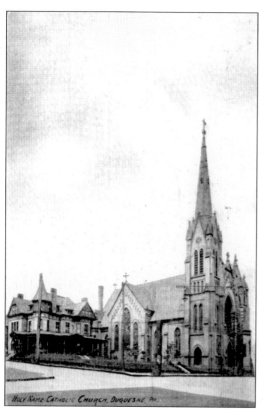

The Holy Name Church is located on South First Street in Duquesne. The cornerstone was laid in 1899, and construction cost $50,000. The postcard to the left is from 1910, while the one below, from the 1940s, reveals the absence of the tall steeple due to fire.

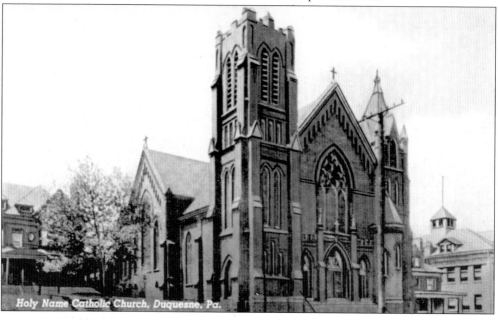

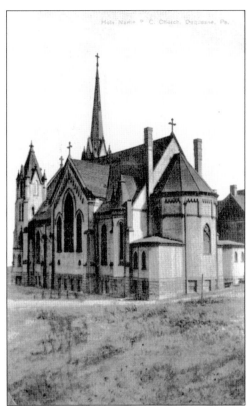

The rare 1910 view to the right was taken from the alley behind the Holy Name Church. Holy Name Parochial School, shown below in 1915, opened in 1909. The building was razed in 2005.

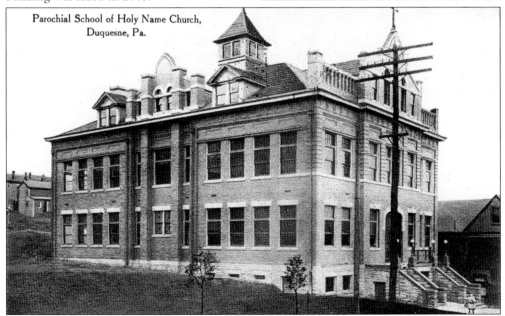

The First Methodist Episcopal Church, located on South Seventh Street in Duquesne, later became the Payne Chapel African Methodist Episcopal, which then moved to Priscilla Avenue. This postcard dates to 1910.

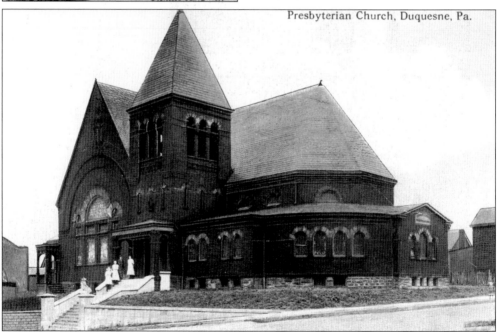

Presbyterian Church, Duquesne, Pa.

Seen in this 1910 postcard, the First Presbyterian Church of Duquesne was first situated at the corner of South Second Street and Viola Avenue. Later, a new building was constructed in the Duquesne Place area.

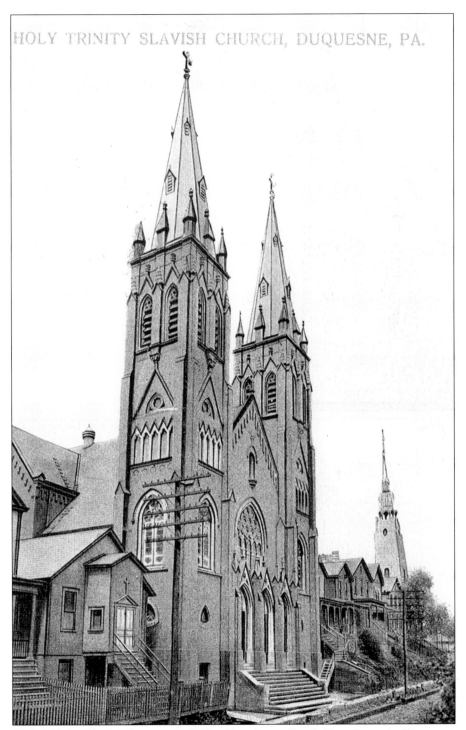

The Holy Trinity Slavish Roman Catholic Church, on South First Street in Duquesne, was completed in 1905. The congregation constructed a new church in West Mifflin in the 1970s, and today the original building stands vacant. In this 1915 postcard, the spires of the SS. Peter and Paul Byzantine Catholic Church on Viola Avenue are visible in the distance.

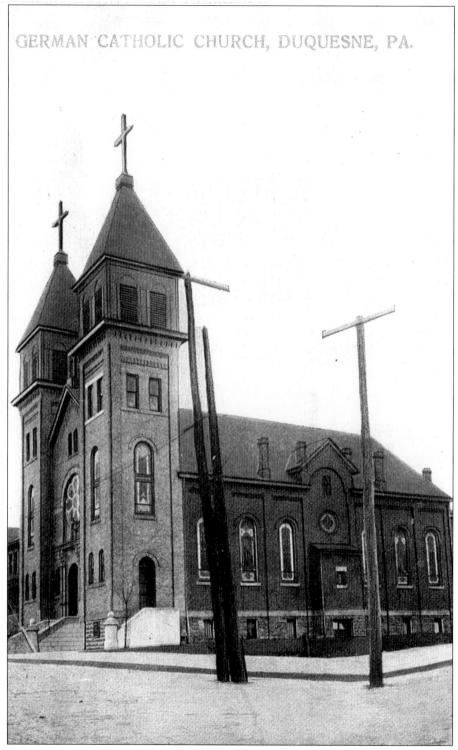

GERMAN CATHOLIC CHURCH, DUQUESNE, PA.

The St. Joseph German Roman Catholic Church is located at the corner of West Grant Avenue and Aurilles Street in Duquesne. This 1915 postcard shows its lofty spires.

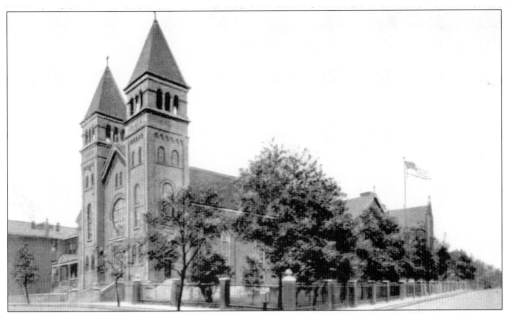

The St. Joseph Church is shown above in the 1920s. The church's parochial school appears to the right in this image. The St. Joseph Parochial School, also pictured below in a 1915 postcard, was demolished in the 1950s and a new one was built.

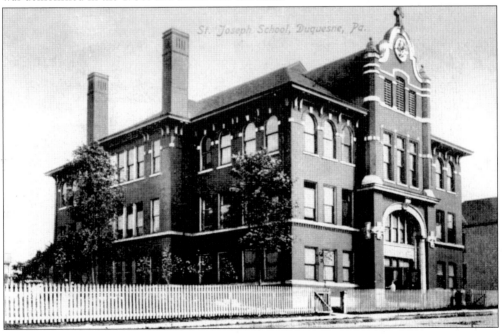

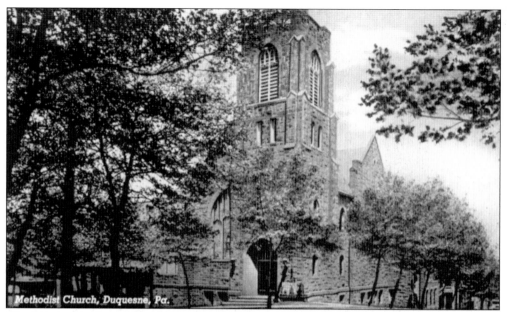

The First Methodist Church of Duquesne, at the corner of South Sixth Street and Kennedy Avenue, is shown here in the 1940s.

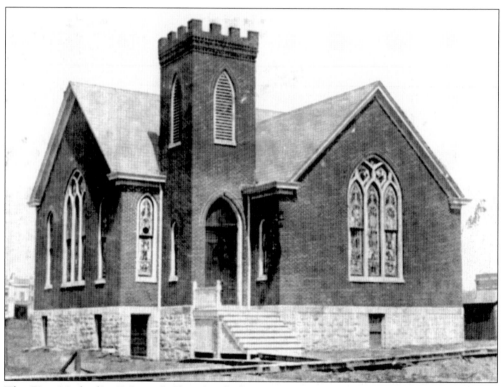

The First Methodist Episcopal Church of Clairton stands proudly on Maple Avenue in this 1905 real photo postcard.

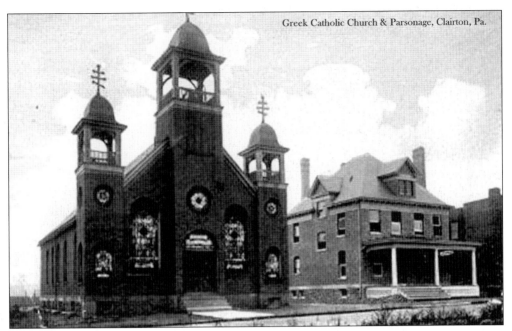

Greek Catholic Church & Parsonage, Clairton, Pa.

This 1915 postcard features the Greek Catholic Church and Parsonage in Clairton.

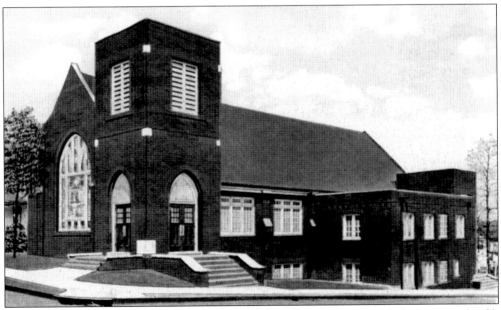

The First Presbyterian Church of Clairton, located on the corner of Waddell Avenue and Fifth Street, is pictured in this 1920s card.

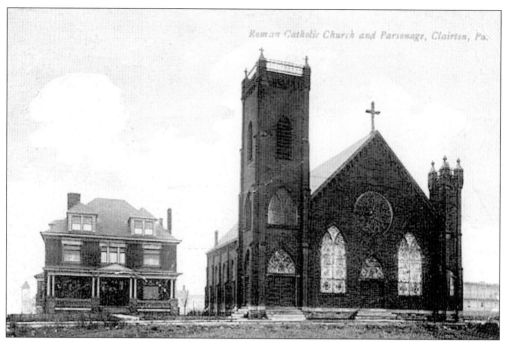

The St. Clare Roman Catholic Church of Clairton appears here in 1910.

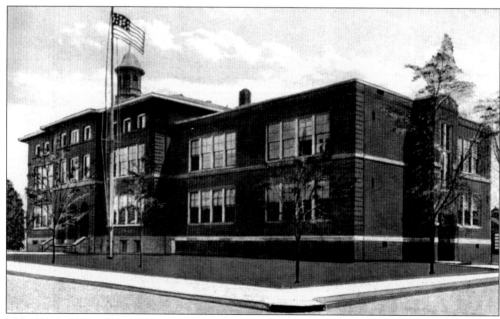

This 1920s postcard reveals Clairton's Fifth Avenue School.

The Walnut Avenue School, shown in this 1940s real photo postcard, was located in the Wilson District of Clairton.

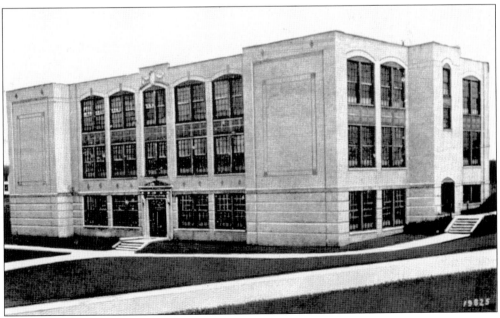

Clairton's Miller Avenue School is pictured here in the 1940s.

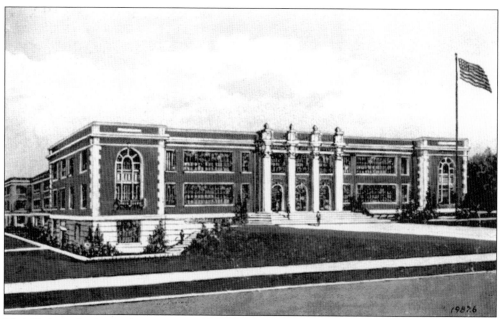

The Clairton Junior and Senior High School, located on Waddell Avenue, is shown in these 1940s postcards. The building has since been completely renovated.

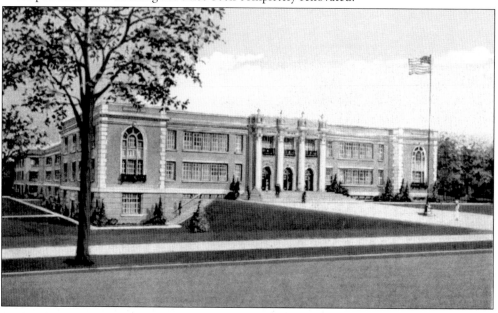

Four

Parks and Recreation

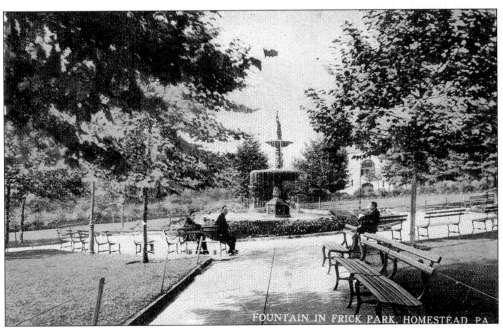

Homestead's Frick Park was built between East Tenth and East Eleventh Avenues with Amity and Ann Streets at its sides. Money with which to plan the park was donated by H. C. Frick in the early 1900s. In this 1915 postcard, two gentlemen take in the view of the water fountain and luxuriously landscaped grounds.

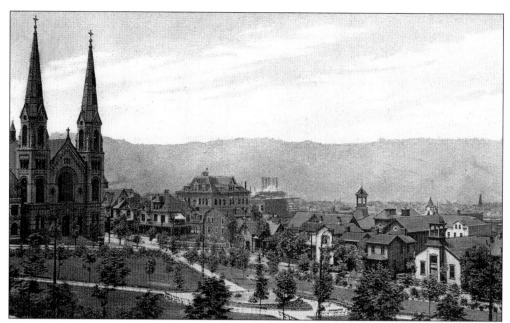

Frick Park is framed by the many churches standing around its perimeter. St. Mary Magdalene Church, with its impressive steeples, is shown to the left in the 1910 postcard above. The 1915 postcard below depicts the pathways and landscaping in the park's early days.

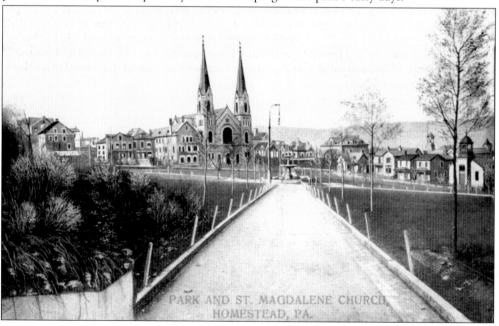

PARK AND ST. MAGDALENE CHURCH, HOMESTEAD, PA.

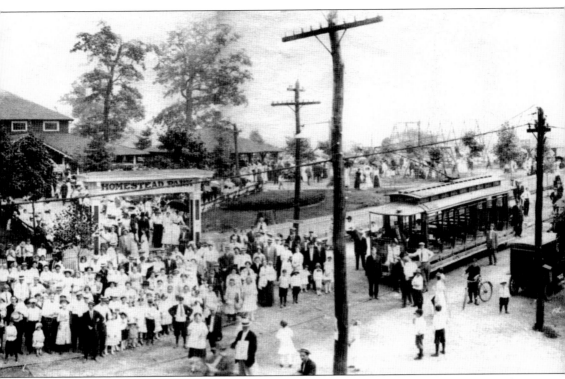

Seen here in a 1913 real photo postcard is the entrance to Munhall's famous Homestead Park, constructed by the Homestead and Mifflin Street Railway Company around 1904. Through the years, the park was the favorite picnic and entertainment area for residents. It closed its doors in the late 1920s, when the Carnegie Land Company purchased the land and developed it into lots for homes.

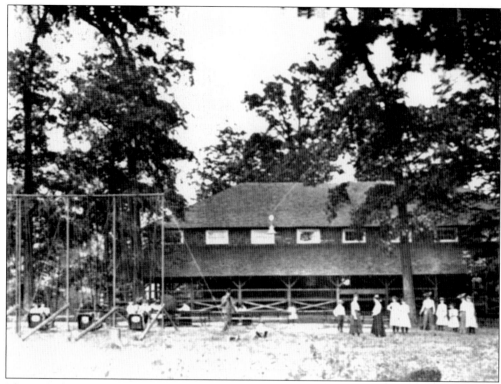

The real photo postcard above reveals the Homestead Park dance pavilion and playgrounds. The postcard below, dated 1915, again shows the dance pavilion.

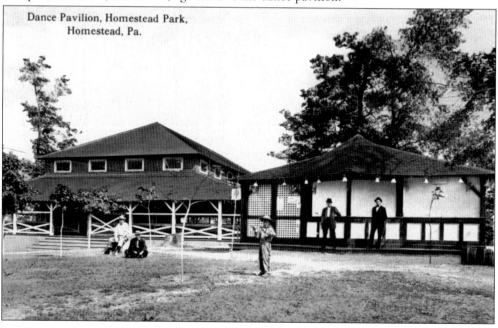

Dance Pavilion, Homestead Park,
Homestead, Pa.

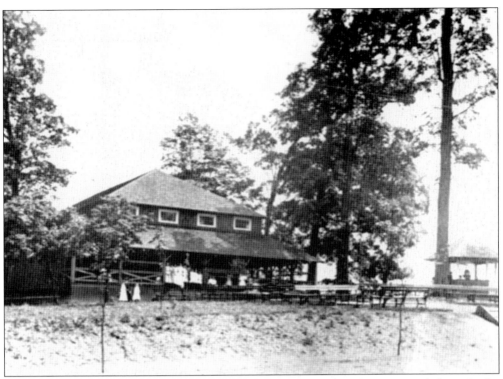

The Homestead Park dance pavilion is the subject of the 1910 real photo postcard above. In the 1918 postcard below, patrons stroll along the many scenic walking paths throughout the park.

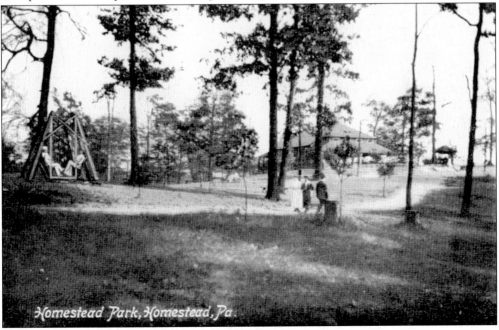

Homestead Park, Homestead, Pa.

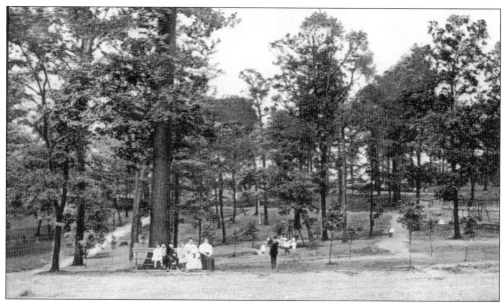

Above, a group of picnickers enjoys the shade under the park's trees in 1917. The real photo postcard below shows the miniature steam railroad, a favorite among patrons both young and old.

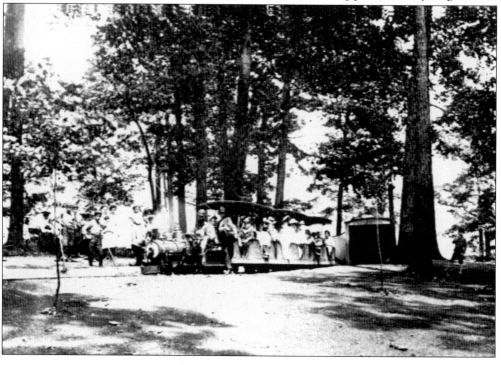

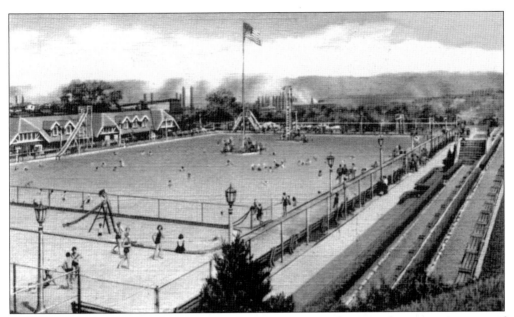

The Clairton Swimming Pool opened on May 30, 1930, after a total construction cost of $107,000. The pool, 210 feet long and 130 feet wide, featured a separate baby pool at the shallow end. It is still enjoyed by local residents today.

The Clairton Park provided many walking paths and spacious grounds for picnickers. This 1930s postcard shows the memorial honoring veterans.

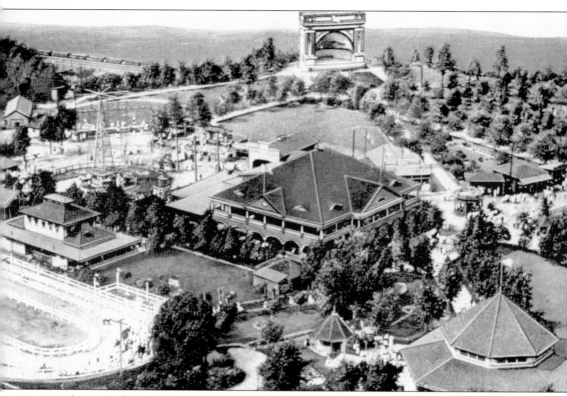

At the end of the 19th century, trolley parks began springing up throughout the county. Kenny's Grove, a favorite picnic area in Mifflin Township, was bought by the Monongahela Street Railway Company in 1898 and named Kennywood Park. The company laid out the park in a practical and functional manner, with the focal point a man-made lake dotted with islands and rustic bridges. In fact, the plan was so good that the park still uses it today. The first major structures were open-air buildings, the dance pavilion, casino, and merry-go-round. This 1915 postcard gives an aerial view of the park. The pony track is to the left, the restaurant in the center, and the carousel to the right. The band shell at the top center was built in 1900 and burned down in 1961.

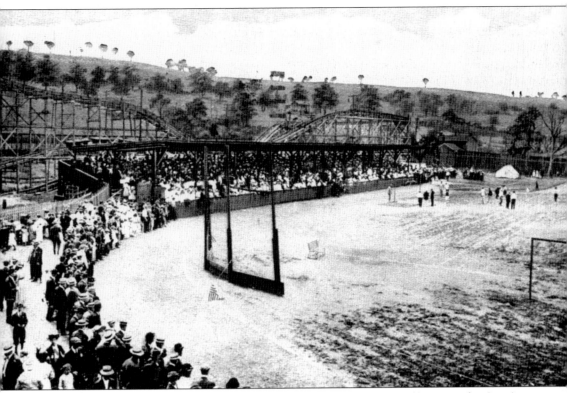

The Kennywood Park athletic fields are captured in this 1912 postcard view. The Scenic Railway coaster appears to the rear of the grandstands. The fields were used for many amateur and semiprofessional baseball games and athletic contests. In the 1920s, the fields were moved across the present-day highway when construction began for the swimming pool.

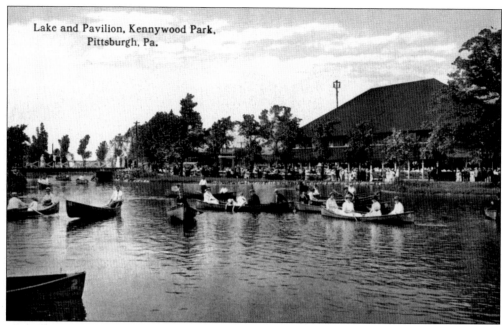

The Kennywood Park lake and dance pavilion are shown in these 1910 postcards. The man-made lake was a favorite to the patrons of the park from its early beginnings and remains so today. Patrons could rent a boat and paddle for a given time period.

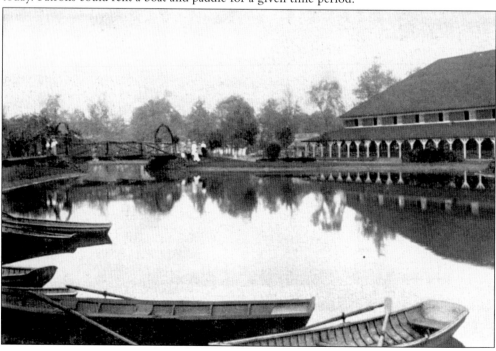

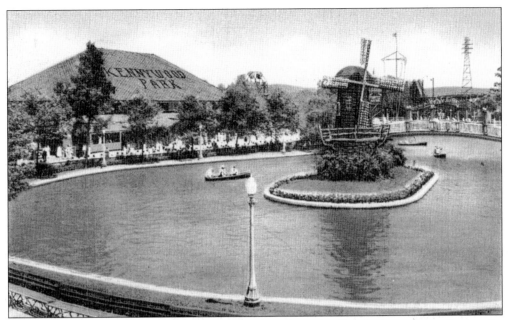

Built in the early 1900s and enclosed in 1934, when the park offered winter roller-skating, the Kennywood dance pavilion became an enclosed ride in the 1960s and burned down in 1975. The above postcard, dating from the 1920s, shows the windmill that was on one of the islands. The restaurant appears in the background of the below 1910 postcard.

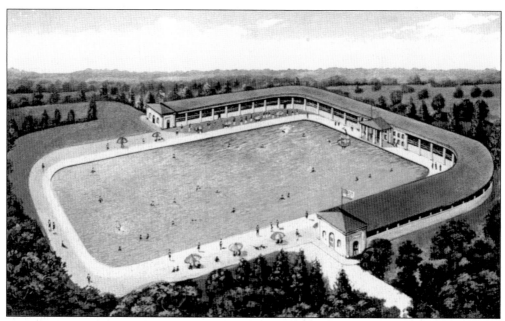

The Kennywood Park swimming pool opened in 1925 as the largest (180 by 350 feet) and most modern pool anywhere in the country. It held some 2.25 million gallons of water. The cost of the pool's construction was $150,000.

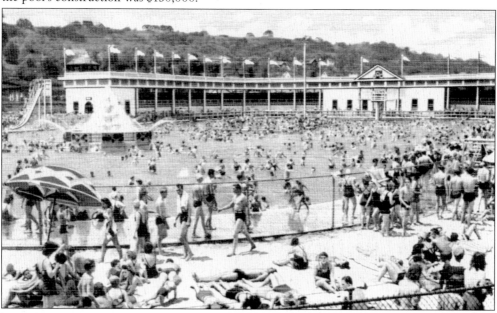

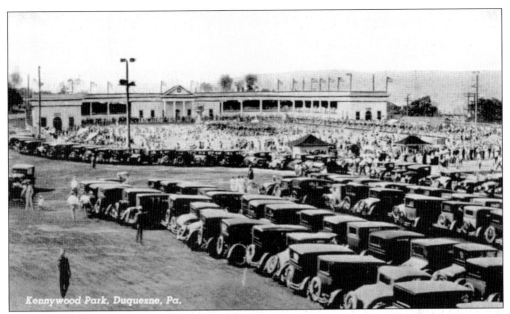

Kennywood Park, Duquesne, Pa.

Though a crowd pleaser, the Kennywood Park swimming pool suffered leaks over the years and closed in 1973. One of its highlights was a 25-foot-wide white sand beach made from 20 railroad cars of sand. As evidenced by the 1930 postcard above, the parking lot next to the pool was always full. In the 1940s postcard below, swimmers enjoy the beach.

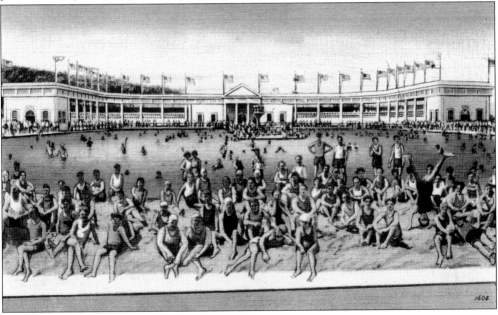

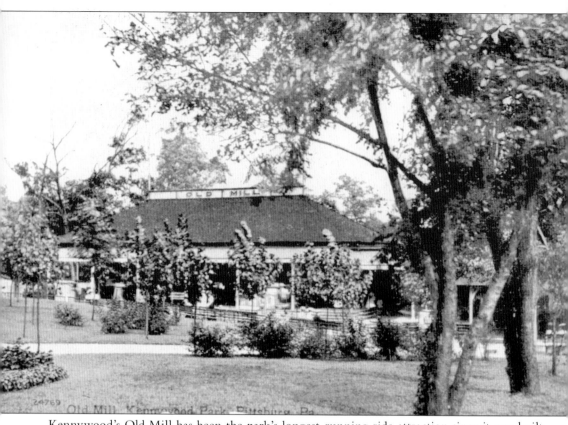

Kennywood's Old Mill has been the park's longest-running ride attraction since it was built and opened in 1901. The ride has reinvented itself many times by adding extra attractions throughout its boat-riding adventure.

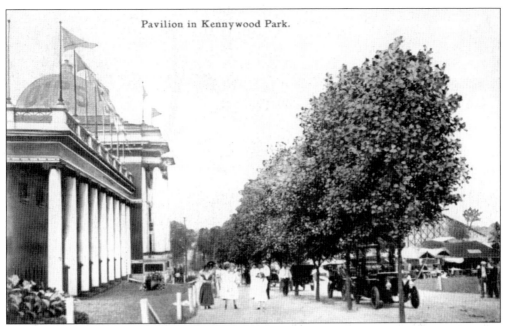

Pavilion in Kennywood Park.

The Dips Pavilion, pictured above in 1905, was an indoor dark ride known as the Daffy Dilla, Tut's Tomb, and in 1915, Hilarity Hall. In later years, it became the popular ride known as the Skooter. The building was razed when the Lost Kennywood section of the park was constructed. The 1905 postcard below shows the pavilion with the Airship ride to the right.

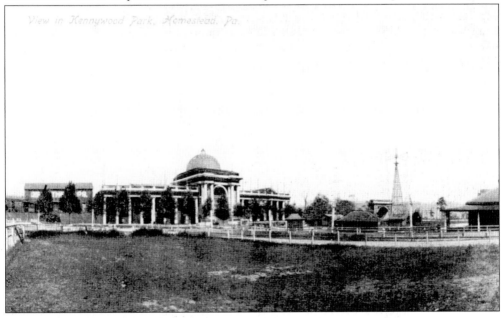

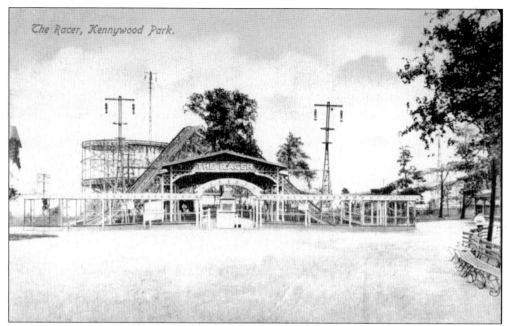

The Racer, Kennywood Park.

Kennywood's original Racer, standing at the site of present–day Kiddie Land, was constructed by the Ingersoll Brothers of Pittsburgh in 1910, when it was known as the Serial Racer. Its unique new coaster design featured cars on adjoining tracks that raced each other. The ride was dismantled in 1927, and the current Racer was built. Both postcards date to the 1915 time period.

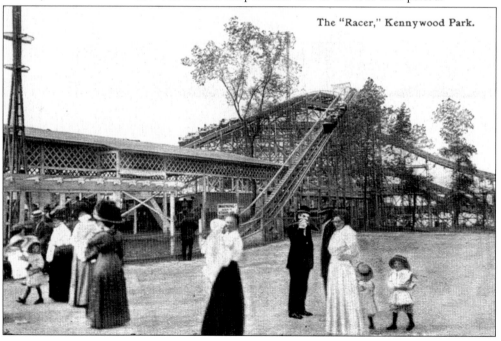

The "Racer," Kennywood Park.

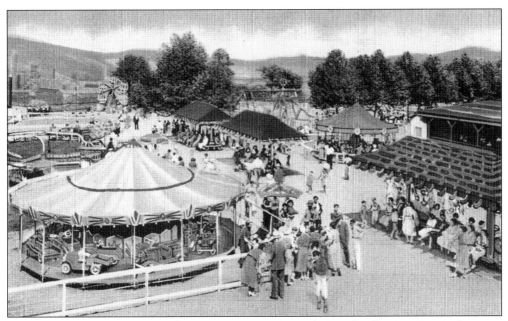

Shown in these 1930s postcards, Kiddie Land was a special place for the youngsters who came to the park. It was originally laid out in 1924 near the Jack Rabbit and included four child-sized rides but later expanded to nine rides. Once the Racer was removed in 1927, this section was greatly expanded for rides for the very young child.

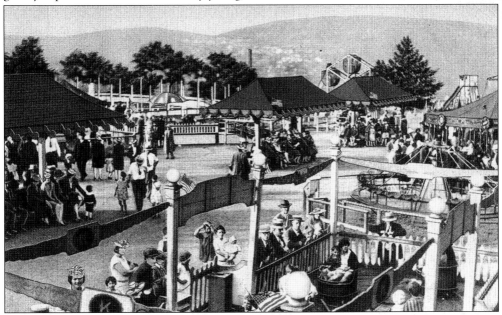

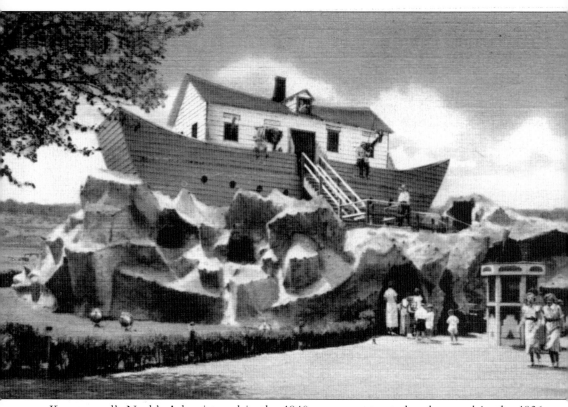

Kennywood's Noah's Ark, pictured in the 1940s, was constructed and opened in the 1936 season. It has been one of the park's most popular walk-through indoor rides. An interesting fact is that the ride opened the summer of the famous St. Patrick's Day flood of 1936. The ride was completely remodeled in the 1990s, and when it opened, another flood struck the Pittsburgh area.

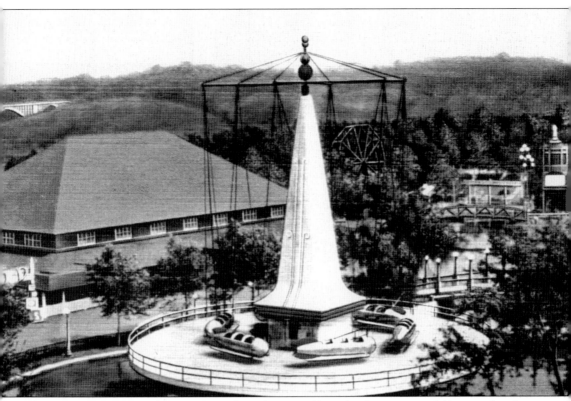

The 1940 construction of the Rocket ride took some 110 yards of concrete and 49 tons of steel when it was built in the middle of the lake. This postcard dates to the 1940s.

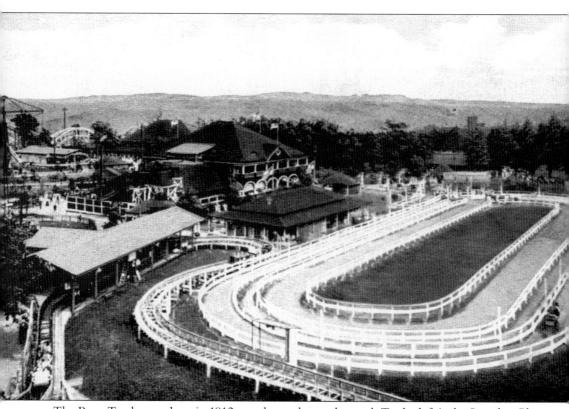

The Pony Track, seen here in 1912, was located near the road. To the left is the Speed-o-Plane coaster building, and beyond is the Airship ride, which featured gondolas made of wicker. In the center of the postcard is the restaurant, one of the oldest buildings in the park.

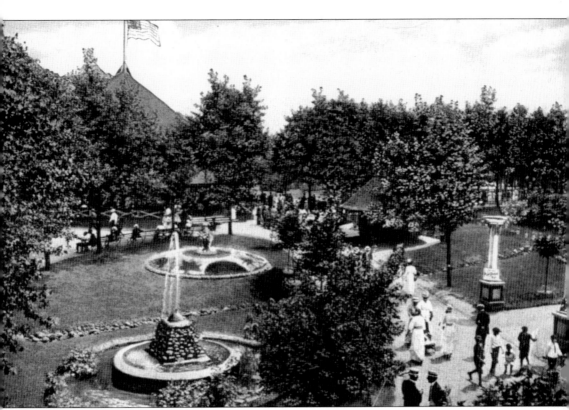

Owners have always been conscious of the attractiveness of Kennywood's landscaping features. The carousel building, with a flag on its roof, appears in this 1915 postcard.

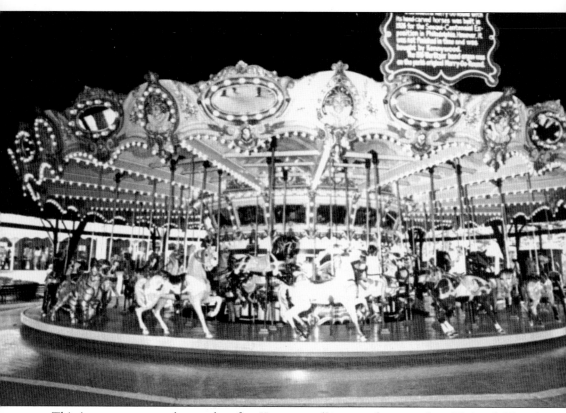

This image was created recently, after Kennywood's carousel was made a National Historic Landmark. In 1927, the park purchased a four-row Dentzel carousel. Unfortunately, this carousel did not fit into the old building, and so a new structure was built to house it. The old building then became a refreshment stand. The carousel features 50 jumping horses, 1 lion, 1 tiger, and 14 stationary horses.